# LAKE DISTRICT

## THE POSTCARD COLLECTION

BILLY F. K. HOWORTH

AMBERLEY

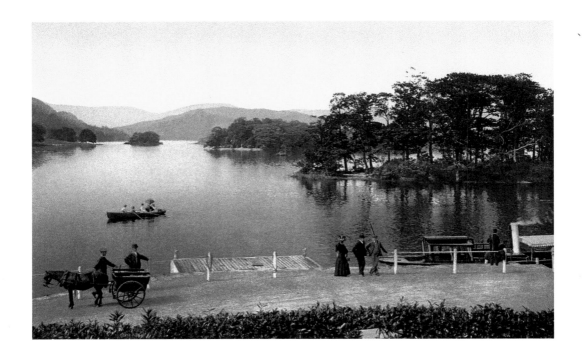

*In memory of my Uncle, Neil Howorth (1961–2007)*

First published 2018

Amberley Publishing
The Hill, Stroud, Gloucestershire, GL5 4EP
www.amberley-books.com

Copyright © Billy F. K. Howorth, 2018

The right of Billy F. K. Howorth to be identified as the
Author of this work has been asserted in accordance with
the Copyrights, Designs and Patents Act 1988.

ISBN  978 1 4456 7416 2 (print)
ISBN  978 1 4456 7417 9 (ebook)

British Library Cataloguing in Publication Data.
A catalogue record for this book is available from the
British Library.

Origination by Amberley Publishing.
Printed in Great Britain.

# CONTENTS

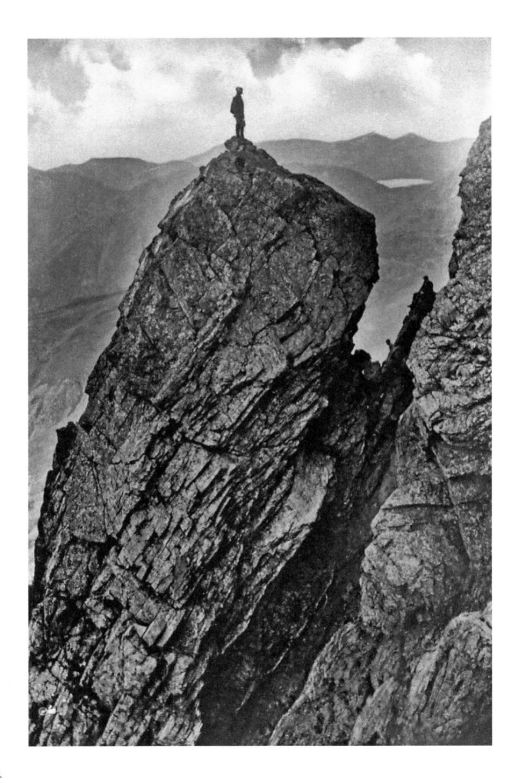

# INTRODUCTION

The Lake District is famous for its majestic lakes, expansive green valleys and towering mountain peaks and is one of the most widely visited destinations not just in the North West, but also in the whole of the UK.

The history of the Lakes can be traced back millions of years to a time when the area was covered in volcanoes, swamps and lagoons and prehistoric beasts roamed the landscape.

The arrival of the first humans in Lakeland during prehistoric times provides us with evidence of how the environment and the abundant natural resources of the area were utilised to support these early settlers. During the Roman occupation of Britain, a series of forts were constructed around the area, connected by roads travelling to the major towns and cities in the south and the strategically important Hadrian's Wall to the north.

During the Middle Ages, the area remained a remote place. Many important abbeys and castles where constructed covering the whole of what is now Cumbria and later, with the arrival of the gentry and their wealth, we began to see construction of many spectacular halls and manors in the region.

The Lake District and its landscape was first captured by the great artists and writers of the eighteenth and nineteenth century, whose work showcased all that Lakeland had to offer. The area underwent its most drastic change with the advent of steam transportation during the Victorian period, which for the first time allowed visitors en masse to explore the area, bringing with them their money and fuelling a boom in the expansion of many small towns including Windermere, Ambleside and Bowness-on-Windermere. Even with the arrival of tourism in the early twentieth century, many of the smaller villages and areas remained cut-off, where life took a different pace.

Today the Lake District retains its power, with inspiring scenery and endless panoramas bringing tourists from far and wide. In July 2017, the Lake District was awarded the honour of becoming a UNESCO World Heritage Site, something which is sure to encourage even more visitors.

Finally, I would like to say that this book would not have been made possible without the work of many different artists and photographers who over the past century have sought to promote the Lake District's towns, sites and landscape through the production of picture postcards. The postcards featured in this book come from my own personal collection and I have tried to bring together a collection of the most impressive images of the area's towns, lakes, mountains and landscapes. I have also attempted to give an overview of how life for the people of Lakeland has changed with the influence of tourism and development over the past two centuries.

# CHAPTER 1

# TOURIST POSTCARDS

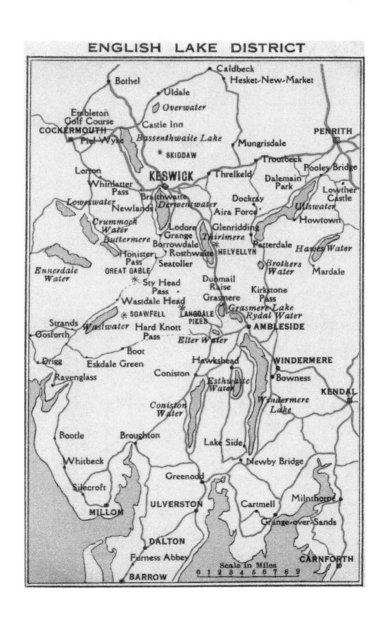

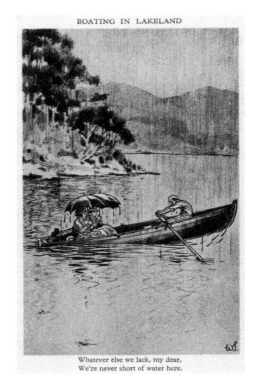

*Touring in Lakeland*

*A Char-a-banc taking a difficult curve,*
*Is an excellent test of the passengers "nerve"*

BOATING IN LAKELAND

Whatever else we lack, my dear,
We're never short of water here.

## Humorous Postcards

One of the most popular items visiting tourists enjoyed to purchase were postcards. Many of those produced for the Lake District often take a humorous look at Lakeland life, portraying comical situations from the British weather to the dangerous roads and mountain passes.

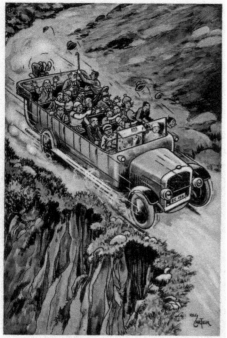

A MOTOR TOUR IN LAKELAND.

If you desire to go the pace,
Try motoring through this lovely place.

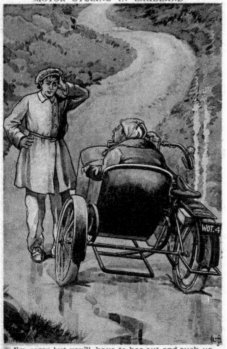

MOTOR CYCLING IN LAKELAND

I'm sorry but you'll have to hop out and push up
this bit, Auntie.

Humorous Postcards II
These comical postcards not only show that life
in the Lakes had its own challenges, but also
ensured that visiting tourists would buy them as
quirky souvenirs to take home with them.

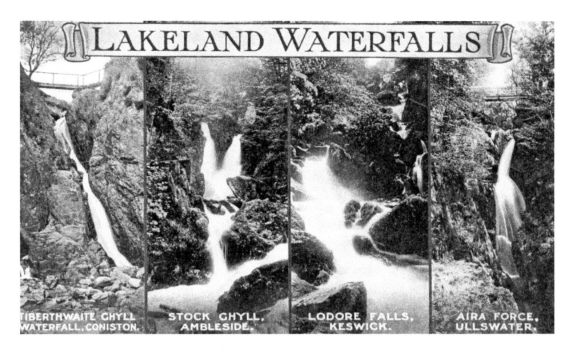

LAKELAND WATERFALLS

TIBERTHWAITE GHYLL WATERFALL, CONISTON.

STOCK GHYLL, AMBLESIDE.

LODORE FALLS, KESWICK.

AIRA FORCE, ULLSWATER.

Multi-views of the Lake District

With the advent of tourists coming to the Lake District during the Victorian and Edwardian period, the idea of promoting the sights of Lakeland through images was first used. These multi-view postcards show a selection of the most famous towns, mountains and lakes that could be found by tourists. This ensured that visitors would not only attempt to see as many places as possible, but also choose to take home postcards to show friends and family.

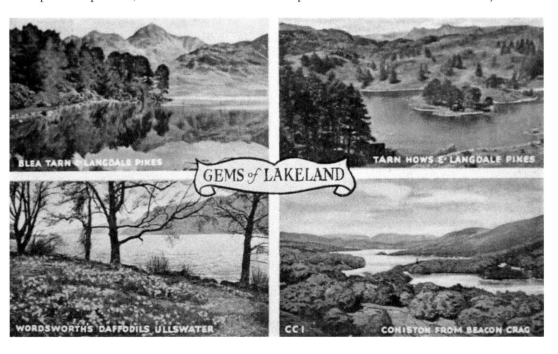

BLEA TARN & LANGDALE PIKES

TARN HOWS & LANGDALE PIKES

GEMS of LAKELAND

WORDSWORTHS DAFFODILS ULLSWATER

CC I

CONISTON FROM BEACON CRAG

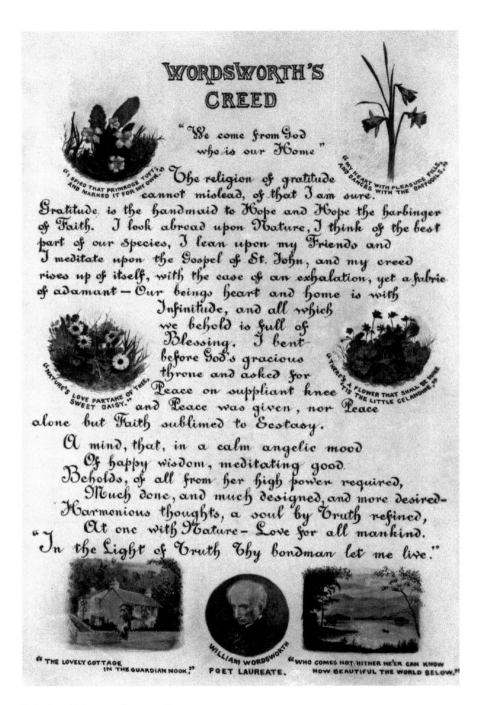

**WORDSWORTH'S CREED**

"We come from God who is our Home"

The religion of gratitude cannot mislead, of that I am sure. Gratitude is the handmaid to Hope and Hope the harbinger of Faith. I look abroad upon Nature, I think of the best part of our species, I lean upon my Friends and I meditate upon the Gospel of St. John, and my creed rises up of itself, with the ease of an exhalation, yet a fabric of adamant — Our beings heart and home is with Infinitude, and all which we behold is full of Blessing. I bent before God's gracious throne and asked for Peace on suppliant knee and Peace was given, nor Peace alone but Faith sublimed to Ecstasy.

A mind, that, in a calm angelic mood
Of happy wisdom, meditating good
Beholds, of all from her high power required,
Much done, and much designed, and more desired—
Harmonious thoughts, a soul by Truth refined,
At one with Nature— Love for all mankind.
"In the Light of Truth Thy bondman let me live."

"THE LOVELY COTTAGE IN THE GUARDIAN NOOK."   WILLIAM WORDSWORTH POET LAUREATE.   "WHO COMES NOT HITHER NE'ER CAN KNOW HOW BEAUTIFUL THE WORLD BELOW."

## Lakeland Literary Connections

When we consider the history of the Lakes, it is closely linked with the great writers of the eighteenth and nineteenth century. Many promotional postcards pay homage to this historic link and one of the most common writers to be found is William Wordsworth, with his inspiring poetry and close links to the village of Grasmere cleverly tied into these postcards.

# CHAPTER 2
# AROUND WINDERMERE

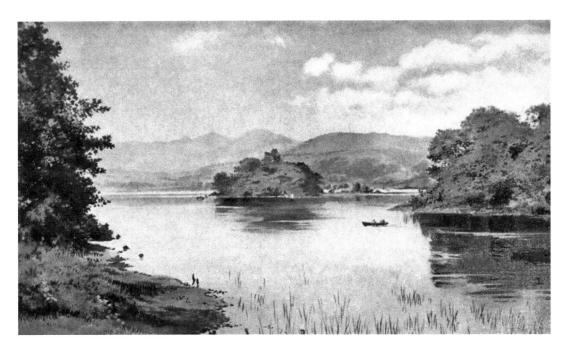

## Windermere: The Lake and Surroundings

Windermere is England's largest natural lake and has been one of the most popular tourist destinations for over two centuries. It is the also the longest of all the Lakes that can be found within the Lake District. Interestingly, there is a debate over the length of the lake and where it should be measured from. When measured from Newby Bridge, the lake is 11 1/4 miles long and almost 1 mile wide.

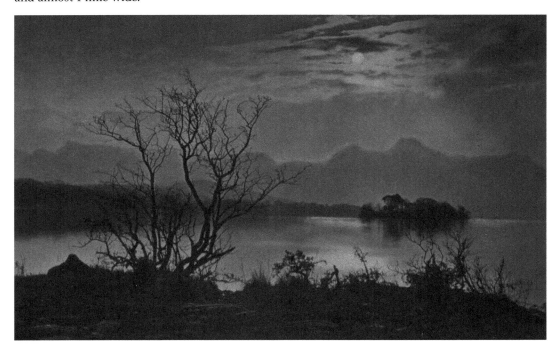

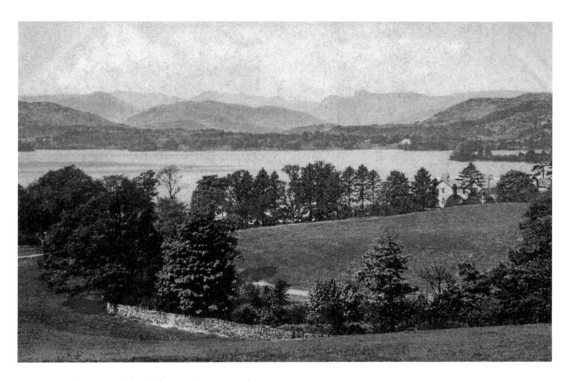

Windermere: The Lake and Surroundings II
The lake is fed by several rivers including the Brathay, Rothay, Trout Beck and Cunsey Beck and is drained by the River Leven at the southern end of the lake. It is also home to eighteen islands, the largest being Belle Isle near Bowness-on-Windermere. Over the centuries the lake has been known by several names including Winander Mere and Winandermere.

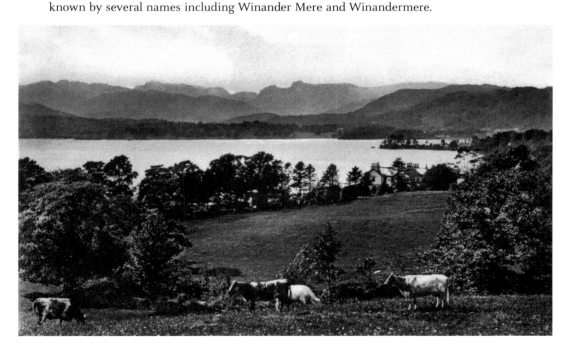

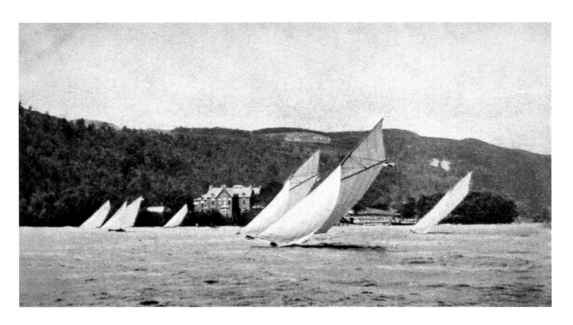

## Sailing on Windermere

Over the centuries Windermere has been a hub of waterborne activity. Its famous ferry has a history stretching back centuries and the later steamers not only provided a vital transport connection but also provided some much-needed relaxation for visiting tourists. The lake has also been a popular recreational area with people choosing to sail small boats and yachts on the lake. The Windermere sailing club was founded in 1860 and began to organise formal races on the lake, bringing in competitors and visitors from far and wide.

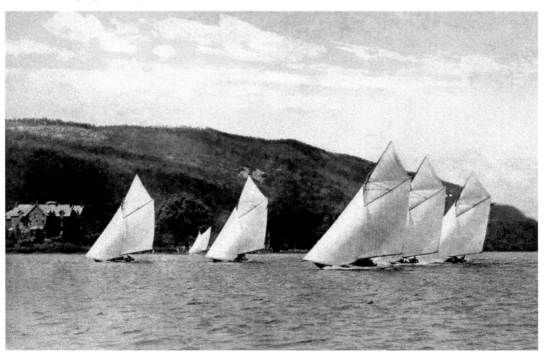

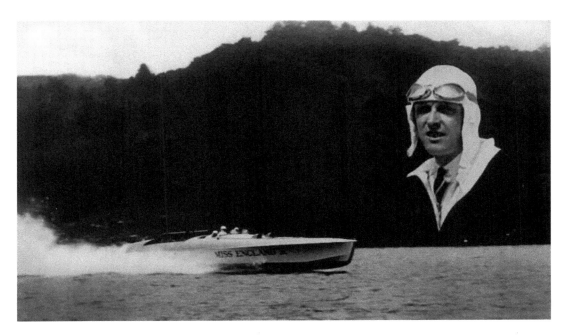

## Water Speed Record Attempts

Windermere has also served as site for world water speed record attempts. The most famous took place on 13 June 1930 when Sir Henry Segrave took to the lake in his boat *Miss England II*. During his attempt he broke the world water speed, travelling at a speed of 98.76 mph. Unfortunately, on the third run his boat capsized while travelling at full speed. His mechanic Victor Helliwell died, but Henry was rescued; however due to the injuries he sustained he passed away shortly afterwards. During the 1950s, the lake was once again host to several world water speed records, undertaken by Norman Buckley.

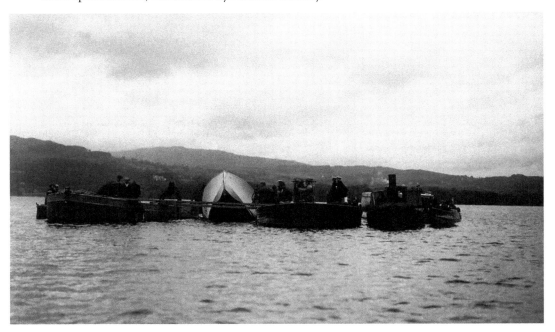

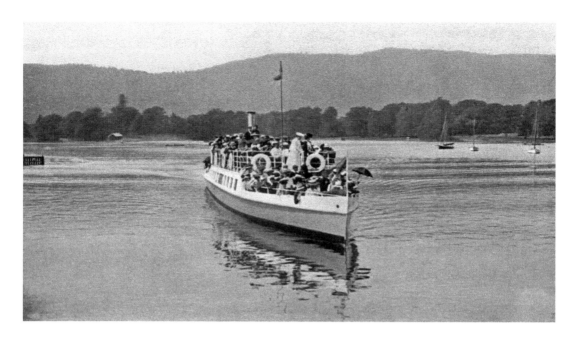

## Windermere Steamers

During the Victorian period, with the introduction of railway routes across Cumbria and the Lake District, the area saw a huge influx of tourists. The first steamer on the lake was the *Lady of the Lake* in 1845, and the boat was operated by the Windermere Steam Yacht Co. It sailed from Newby Bridge northwards to Ambleside, a journey of around seventy-five minutes. Other boats tried to compete with this service; however they had longer journey times of up to three hours and suffered from low passenger numbers. This steamer service became so successful in its first year that a year later a second boat was launched, this time called the *Lord of the Isles*.

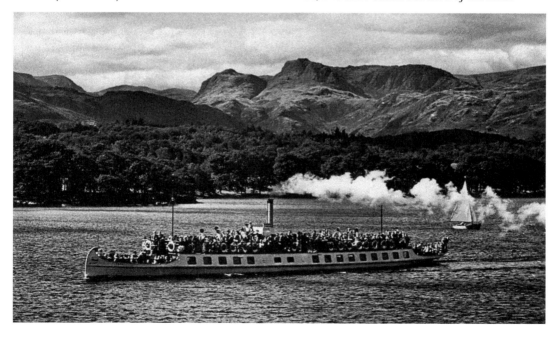

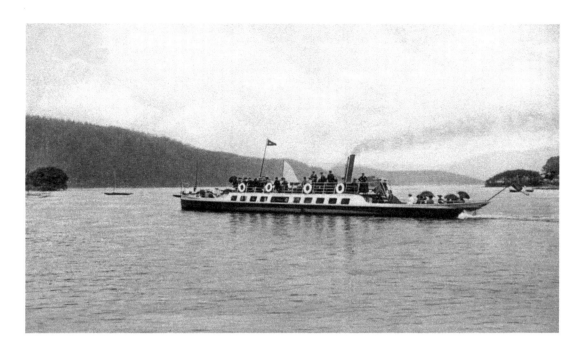

## Windermere Steamers II

The Windermere steamer service found further success when the Kendal and Windermere Railway opened in 1847, allowing even more tourists to visit the area. Over the subsequent decades several other steamers were constructed including the *Swan* (1869), *Cygnet* (1879), *Teal* (1879), *Tern* (1891) and *Swift* (1900), and of these original steamers only the *Tern* is still in service. Later, during the 1930s, two new ships were constructed and named after the original, now decommissioned *Swan* and *Teal* ships. These two newer ships are also still in use to this day and can often be seen sailing across the Windermere.

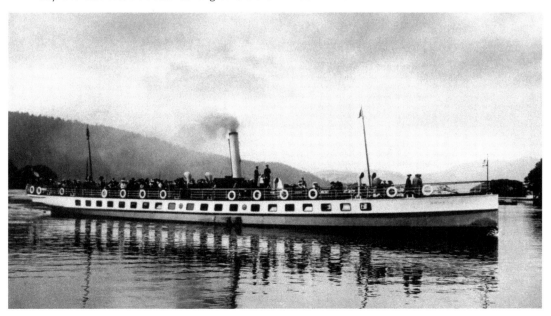

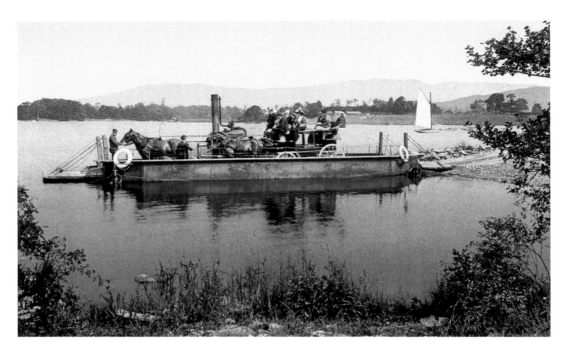

### The Windermere Ferry

The famous Windermere Ferry has origins that can be traced back over 500 years, with the original boats being powered by oar and later by steam. The current ferry service has been in operation since 1900 and is called the *Mallard*. The ferry uses a cable system to move the boat from Ferry Nab to Far Sawrey on the western side, a distance of almost 500 metres. The current ferry is diesel powered and has the ability to carry around 100 passengers and eighteen cars. Without the ferry, a journey of around 15 miles would be necessary to travel to the opposite side of the lake.

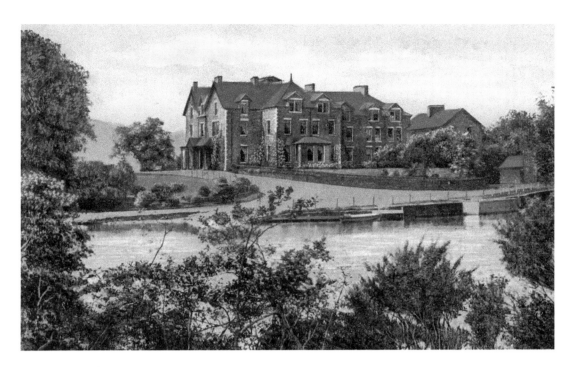

Ferry Nab

The Bowness-on-Windermere side of the lake is the location of Ferry Nab, the eastern point of the Windermere Ferry. This location has always been a vital stopping point with visitors using the ferry and travelling through the Lake District. Due to the number of passing visitors it has been home to several large hotels where travellers could rest and unwind in comfort while taking in the majestic views of Windermere and the surrounding landscape.

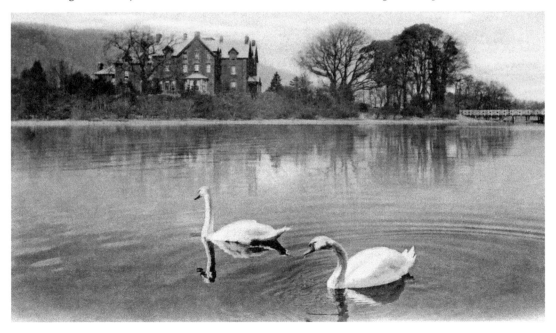

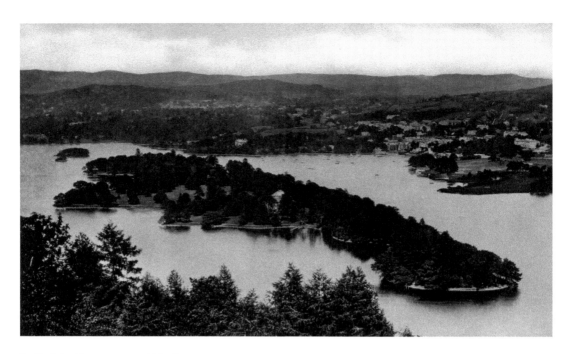

Belle Isle, Bowness-on-Windermere

Close to Bowness-on-Windermere is Belle Isle, the largest island on Windermere. The island has been occupied since Roman times when a villa was constructed on the island for use by a Roman governor in nearby Ambleside. Later, during the Civil War, it became Royalist stronghold. In 1774, the impressive Belle Isle House was constructed by the Curwen family who owned the island; they also renamed the island after their daughter Isabella. Before this time, the island was known by several other names including Long Holme, Longholm and Great Island. Subsequent generations of the Curwen family continued to live on the island until the house was sold in 1993.

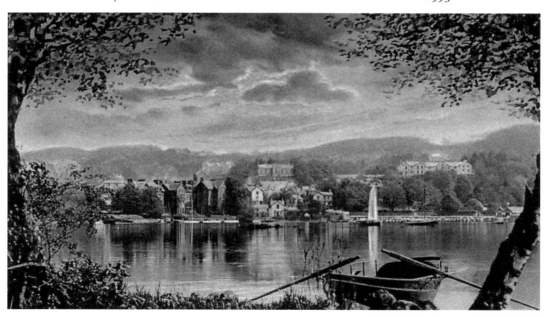

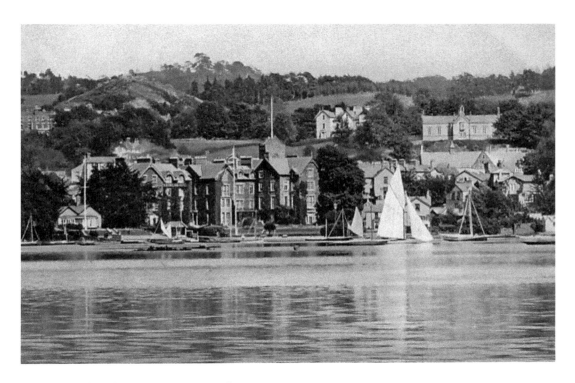

## The Lakeside, Bowness-on-Windermere

The Lakeside area of Bowness-on-Windermere is one of the best known and most visited parts of the town. For over a hundred years it has served as the vital mooring area for the Windermere Steamers as well as being home to many other boats, and its original promenade with wooden buildings reminds visitors of its Victorian past.

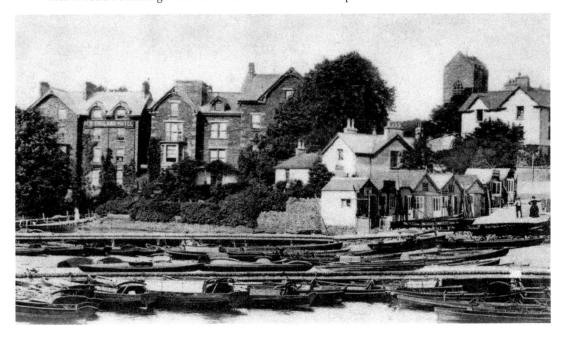

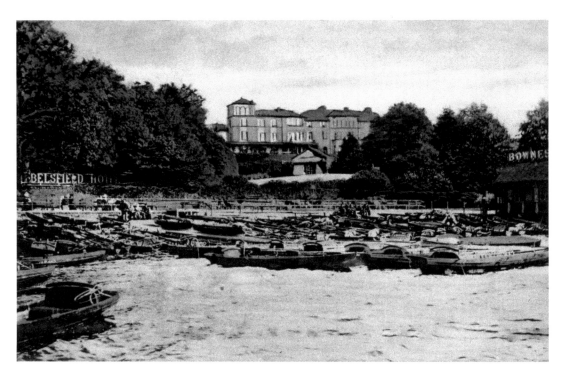

The Lakeside, Bowness-on-Windermere II
This part of the town and lakeside are also dominated by many large hotels including the Old Windermere and the famous Belsfield Hotel. The Belsfield was originally constructed as a house by architect George Webster for the Barrow-in-Furness industrialist H. W. Schneider. Later, in 1890, the house was converted into the current Belsfield Hotel.

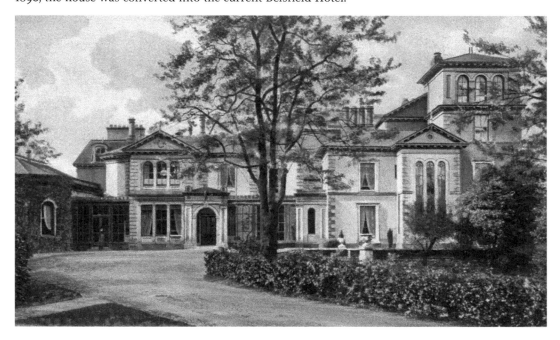

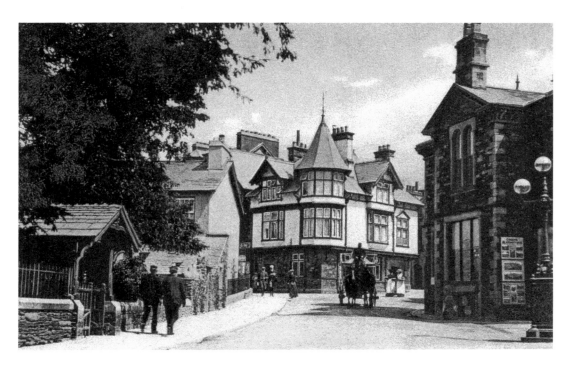

Town Centre, Bowness-on-Windermere II

The centre of Bowness is also the home of many unusual buildings and is a maze of small streets and alleyways. One of the most famous hotels in the centre is the Hydro Hotel, which is one of the oldest hotels in the Lake District. It was built in 1881 as a hotel offering to cure illness with water cures. The town centre is also home to St Martin's Church and the famous World of Beatrix Potter attraction.

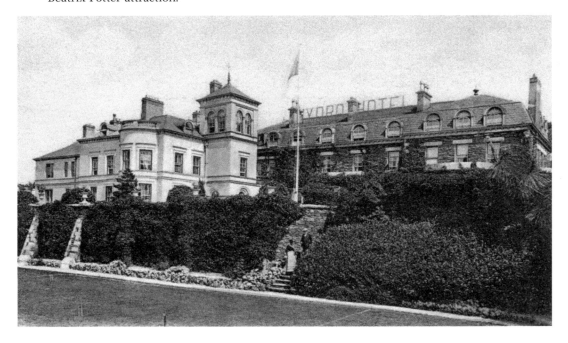

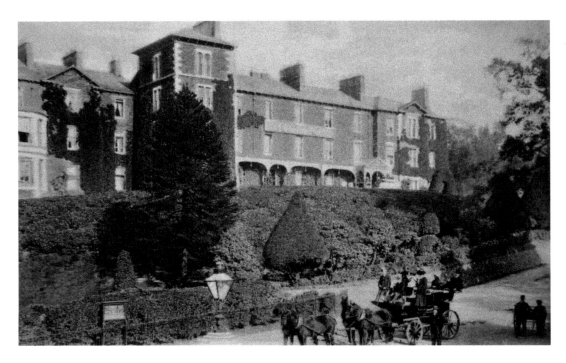

Town Centre, Windermere I
The town of Windermere is located around half a mile uphill from the town of Bowness-on-Windermere. Originally the town was known as Birthwaite and was a small village supporting the local population and was less well known than its lakeside neighbour Bowness. Nowadays the town is a very popular tourist destination attracting visitors to its unique town centre.

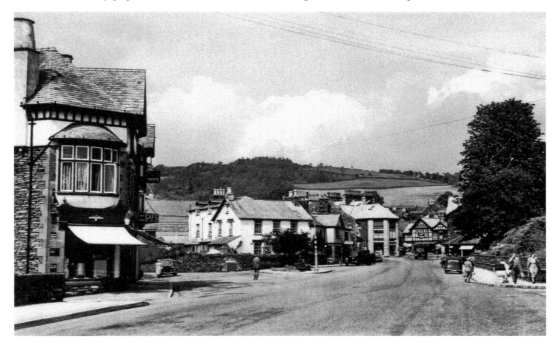

Town Centre, Windermere II
The arrival of the railway in 1847 allowed the town to rapidly expand and many large hotels were constructed to provide accommodation for the new influx of visitors. One of the town's most important and imposing hotels is the Windermere Hotel, originally known as The Riggs Windermere, which opened at the same time as the railway. It is situated high above the main town centre and provides an impressive vantage point of the nearby lakes and mountains.

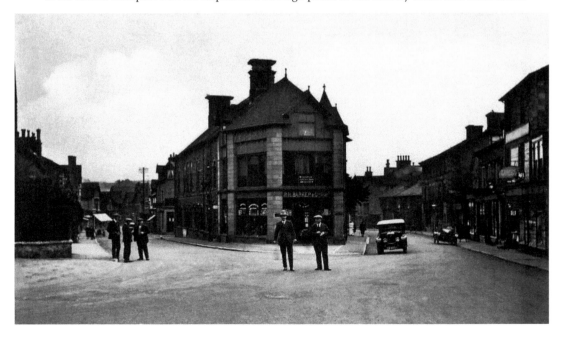

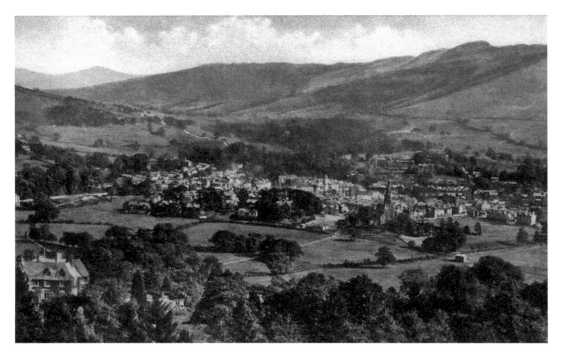

## Ambleside and Surroundings

At the northern end of Windermere is Ambleside and Waterhead, the final stopping point for visitors before heading towards Grasmere and Keswick. The town is famed for its traditional Lakeland character and is a common base for mountaineers, hikers and bikers wanting to explore the central Lakes.

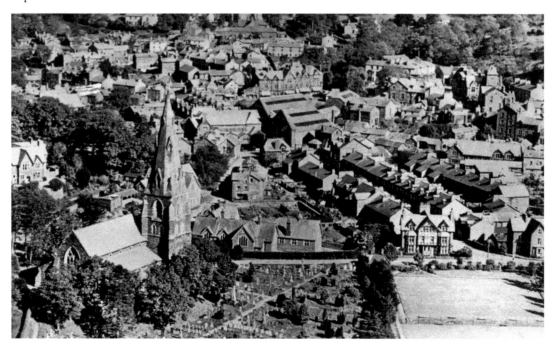

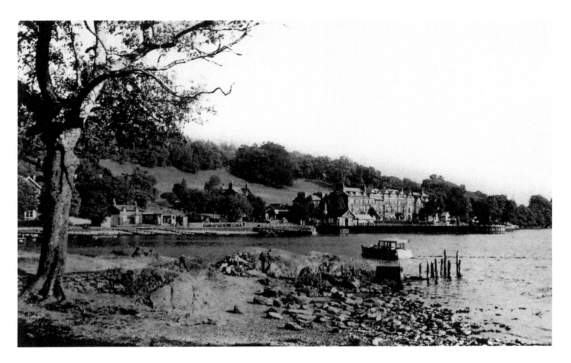

## Waterhead, Ambleside

Close to Ambleside by the edge of Windermere lies Waterhead. This area serves as Ambleside's lakeside connection with the other towns around the lake and is a stopping point for the Windermere Steamers. Close to the docks you also find a small terrace of hotels and houses, as well as a couple of larger hotels.

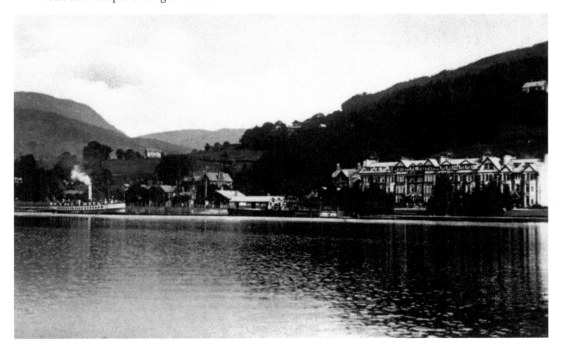

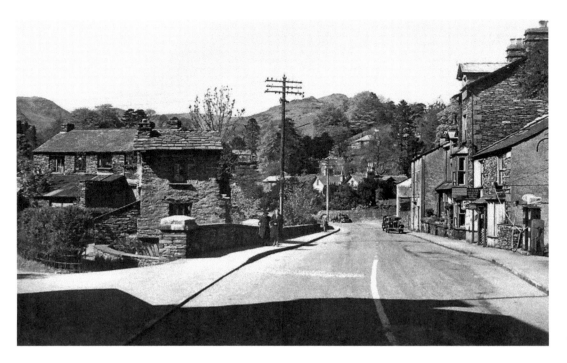

Town Centre, Ambleside

The centre of Ambleside is maze of winding streets and alleyways, making it a popular destination with tourists. If you take a closer look at the buildings in the town you can see that they are constructed using local materials including slate. Ambleside is home to many popular sites including the famous Bridge House and the watermill at Bark Mill, originally used to power machinery for manufacturing wooden bobbins.

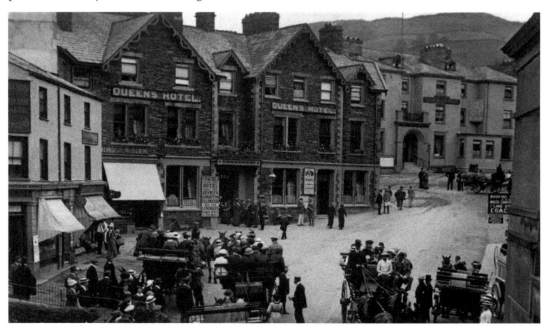

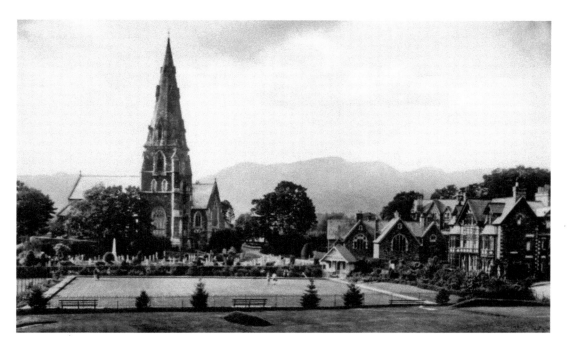

## Town Centre, Ambleside II

Ambleside in the modern day is a bustling tourist hub, but its history stretches back almost 2,000 years to the Roman Occupation. On the edges of Windermere close to Waterhead are the remains of the Roman fort of Galava. The fort was constructed around AD 79 and was used as a base to protect the trade routes that ran through the Lake District to the northern frontier. Galava was excavated by R. G. Collingwood between 1914 and 1920. During the excavations he unearthed the remains of the main gate, granaries and various other buildings. The artefacts that were uncovered can now be found on display at Kendal Museum.

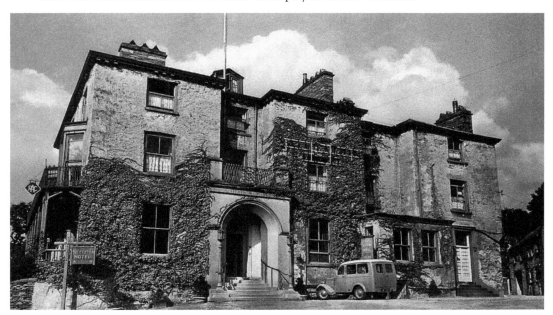

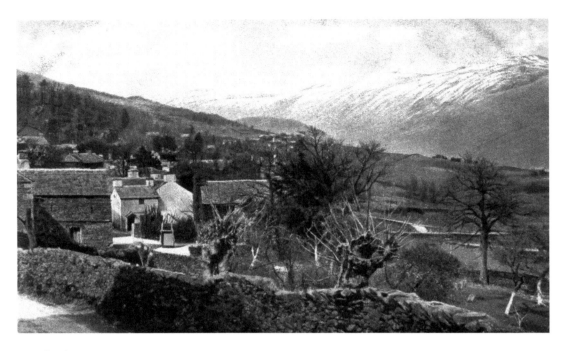

## Troutbeck

Troutbeck is a small, secluded village close to the town of Windermere and one of the lesser-known gems of the Lake District. The village marks a stopping point on the original coaching route over Kirkstone Pass and on to Penrith. The National Trust property of Townend, built in 1626 for George Browne, is located in the village, as well as the popular Holehird Gardens.

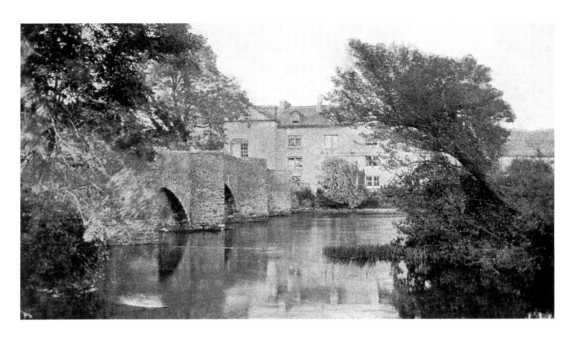

## Newby Bridge

Newby Bridge is a small hamlet located at the southern end of Windermere. The history of the area is closely associated with farming and later with small-scale industries including the manufacture of wooden bobbins. Nowadays, it is best known for its impressive stone bridge which crosses the River Leven and connects both sides of the river. This picturesque part of the river has always been a popular destination for relaxation and during the Victorian period was a popular spot for sailing small boats and rowing. Close by is Lakeside, the final stopping point for the Lakeside and Haverthwaite Railway.

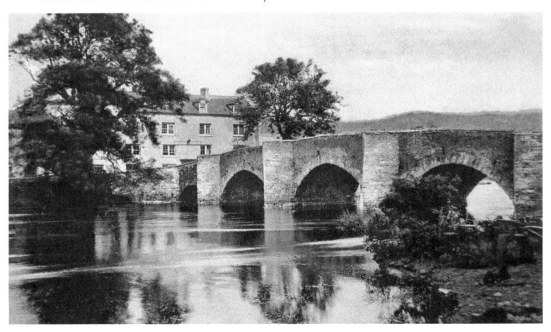

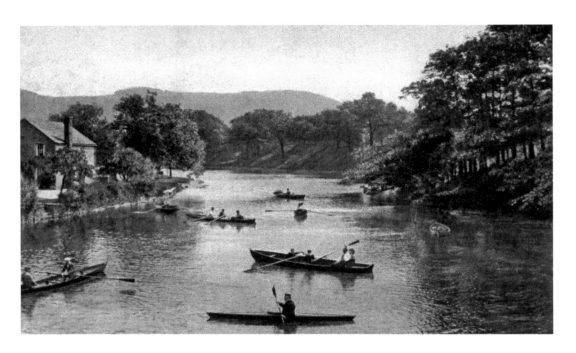

Newby Bridge II
One of the most famous buildings at Newby Bridge is the Swan Hotel. The current hotel stands on the site of an original dwelling dated to around 1623. During the eighteenth century the current building underwent a series of alterations and extensions. The hotel sits of the banks of the River Leven close to the southern end of Windermere and located close to the main transportation route between Kendal, Ulverston and Barrow.

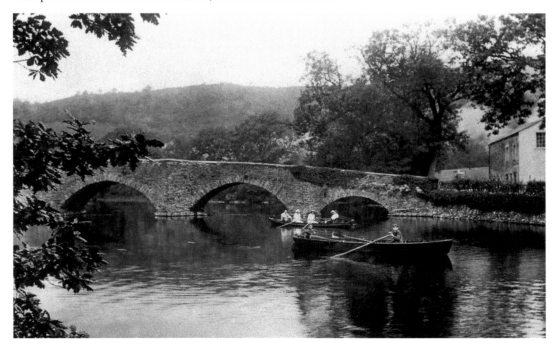

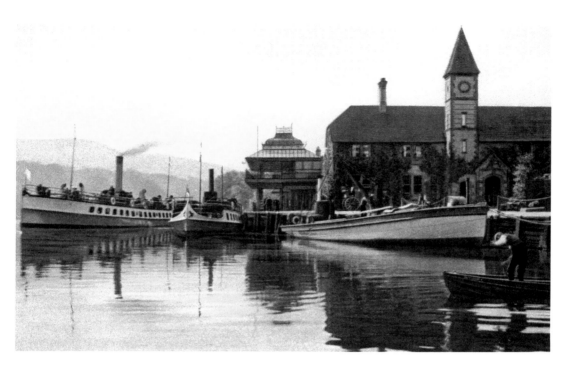

## Lakeside

Lakeside came about with the introduction of railways to the area and the need for a dock at the southern end of Windermere that could accommodate the Windermere Steamers, which were also owned by the railway company. The station at Lakeside is the final stopping point for the Lakeside and Haverthwaite Railway, which originally formed a branch line of the Furness Railway and opened in 1869. This railway was closed in 1965 and reopened in 1973 as a new historic preservation line.

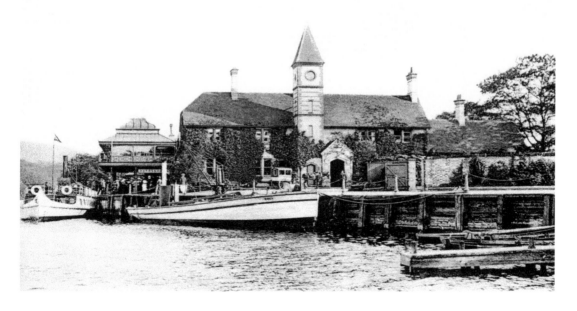

# CHAPTER 3
# THE LAKES

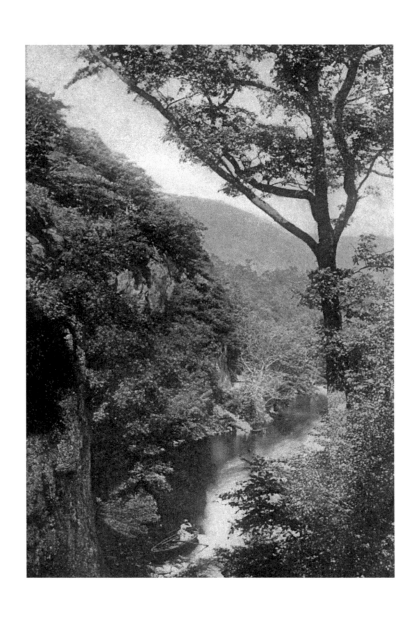

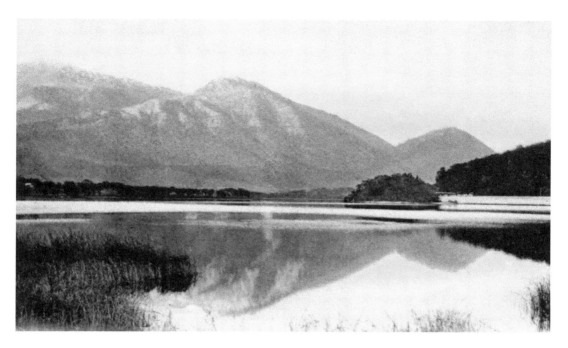

## Bassenthwaite Lake

Bassenthwaite Lake is located in the north-western part of the Lakes and is one of the largest lakes in the Lake District. It is around 4 miles long and 3/4 mile wide. It is fed by the River Derwent and is located at the foot of Skiddaw, with the town of Keswick nearby. Interestingly it is also the only lake in the Lake District to use the word 'Lake' in its name. Over the centuries it has also been known by other names including Broadwater and Bassenwater.

Buttermere
Buttermere is located in the western part of the Lake District. The lake is 1 1/4 miles long by 1/4 mile wide. The lake is fed by the River Cocker, which flows through the lake and the nearby Crummock Water towards the town of Cockermouth, where it joins the River Derwent. The nearby village of Buttermere is located on the north-western side of the lake. The surrounding area is home to several fells including Haystacks, High Stile, Fleetwith Pike and Grasmoor.

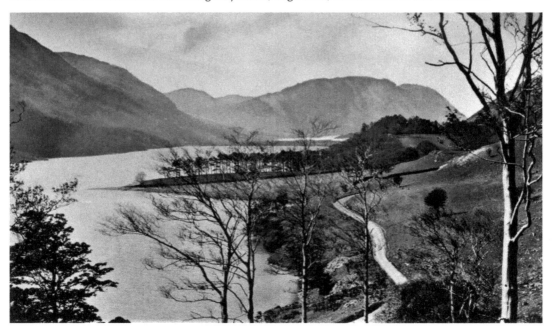

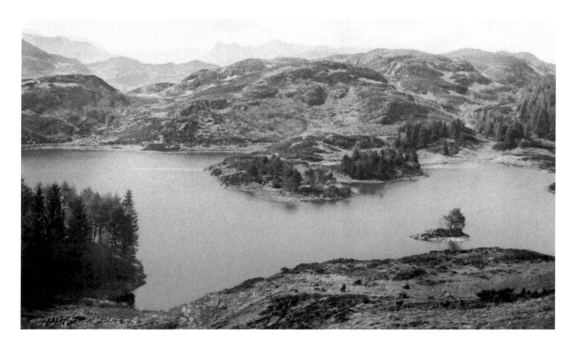

## Coniston Water

Coniston Water is located in the central Lakes. The lake is the third largest in the Lake District at around 5 miles long and 1/2 mile wide and the lake drains into the River Crake. Until the eighteenth century it was also known as Thurston Water. The area has a long history of farming dating back to at least the Bronze Age. It was also an important area for copper mining during the Roman occupation and later became known for its potash kilns and iron bloomeries during the Middle Ages. One of the most famous houses in the area is Brantwood, located on the eastern side of the lake and home to John Ruskin between 1872 and 1900.

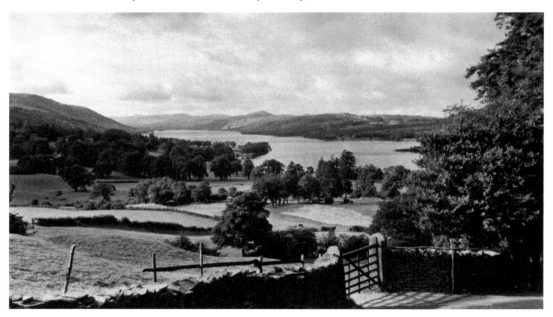

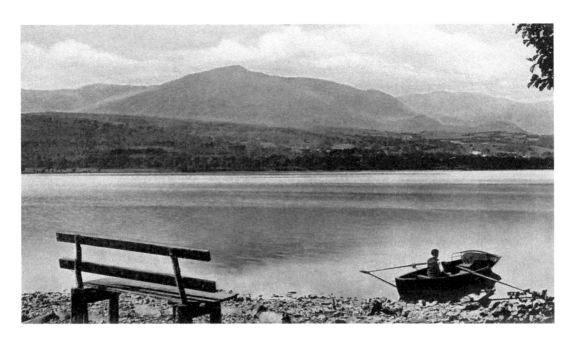

## Coniston Water II

Coniston Water is most famous as a location for world water speed records. The first of these took place in 1939, when Sir Malcolm Campbell travelled at 141.74 mph in Bluebird K4 and set a new record. Later, during the 1950s, his son Donald took to the water, setting four new records in Bluebird K7 between 1956 and 1959. The most infamous of these record attempts took place on 4 January 1967 when Donald achieved a top speed of over 320 mph in Bluebird K7. Sadly on his return leg he lost control. The vehicle crashed and sunk and Donald was killed instantly. The remaining parts of Bluebird, as well as Campbell's remains, were finally recovered from the lake bed in 2001.

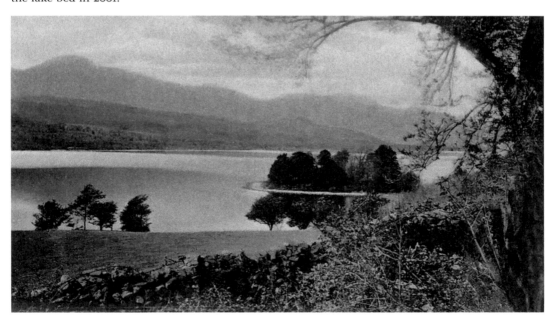

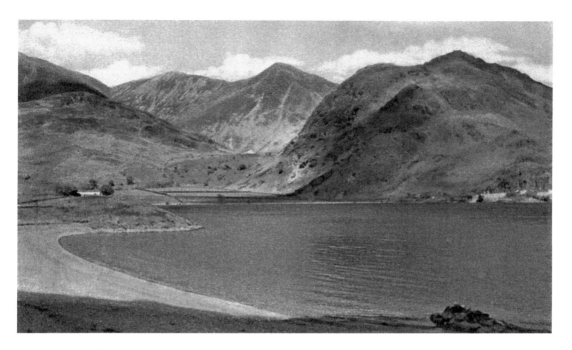

Crummock Water

Crummock Water is located in the western area of the Lakes between Loweswater and Buttermere and measures around 2 1/2 miles long and 3/4 mile wide. The north of the lake also marks the starting point of the River Cocker and is fed by Scale Force, one of the tallest waterfalls in the area. The lake is also important as it provides a source of water for the nearby towns. Water is pumped out from the Cornhow treatment works and supplied to the surrounding villages and towns including Maryport, Whitehaven and Workington.

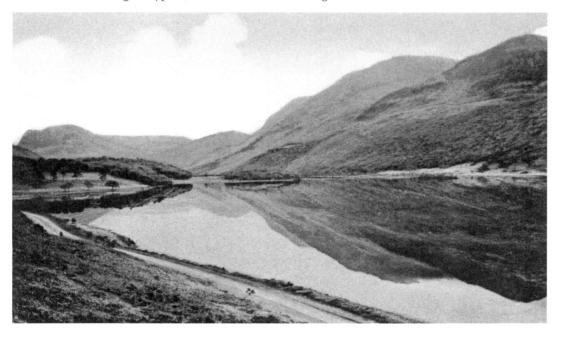

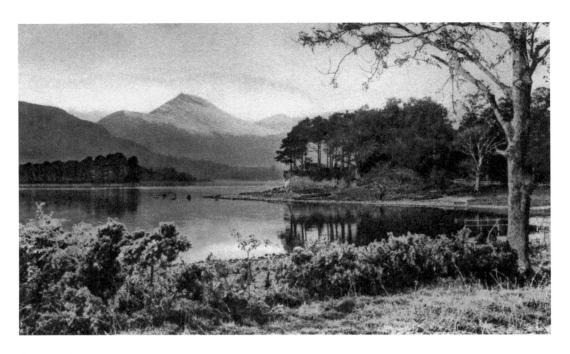

## Derwent Water

Derwent Water is located in the north-western Lakes and is around 3 miles long and 1 mile wide. Unusually the lake is both fed and drained by the River Derwent, which travels through it. The lake is also home to several islands but only Derwent Island is occupied. The lake is a popular destination for tourists and there are boat docks around the lake where tourists from Keswick and Portinscale can hire boats. In the eighteenth and nineteenth century the lake was known by various other names including Keswick Water, Keswick Lake and Lake of Derwent.

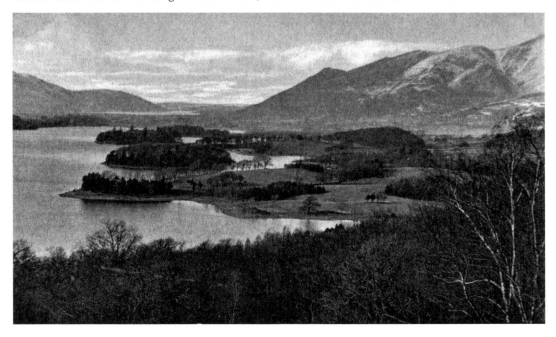

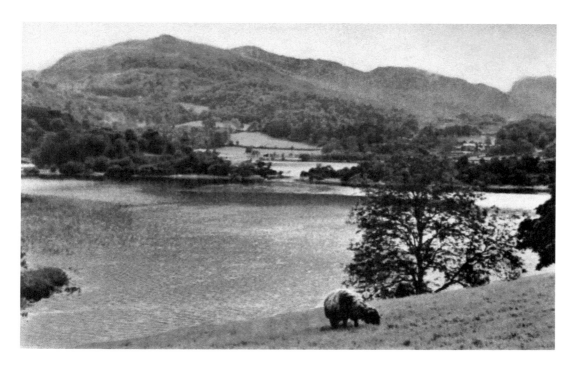

## Elter Water

Elter Water is located in Great Langdale and is one of the smallest lakes, measuring just over 1/2 mile long and almost 1/4 mile wide. The lake is drained by the River Brathay, which travels southwards eventually draining into Windermere, close to the town of Ambleside. The closest village is Elterwater, which is around 1/2 mile north-west from the lake. Unusually, all forms of navigation are banned on the lake.

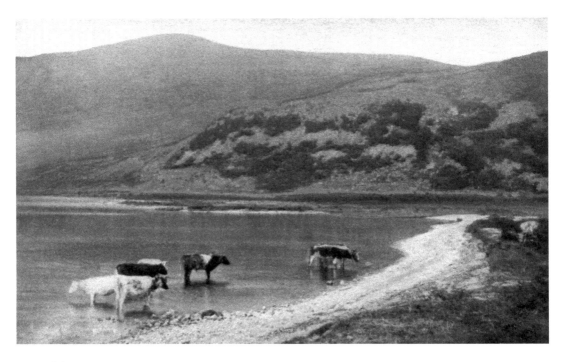

## Ennerdale Water

Ennerdale Water is located in the western Lakes and is around 2 1/2 miles long and 1 mile wide with the lake being fed by the River Liza and drained by the River Ehen. It is located close to town of Whitehaven on Cumbria's western coast. Over the centuries it has been known by various names including Ennerdale Lake, Brodewater, Brodwater and Broad Water. The lake is also surrounded by some of the most famous mountains and peaks including Great Gable and High Crag.

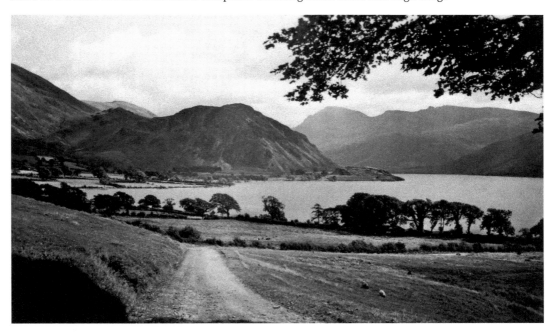

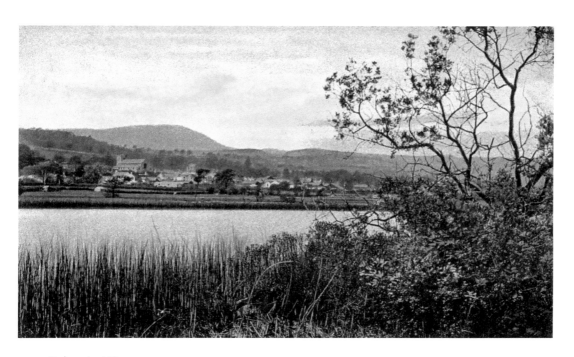

Esthwaite Water

Esthwaite Water is located in the central Lakes between Windermere and Coniston Water. It is one of smallest, least-known lakes covering an area of around 280 acres, with the village of Hawkshead located to the north of the lake. The lake is notable because of its wide diversity of wildlife and is home to many fish species, making it a popular fishing destination. The lake is also rich in nutrients that allow a large variety of water-dwelling plants to thrive.

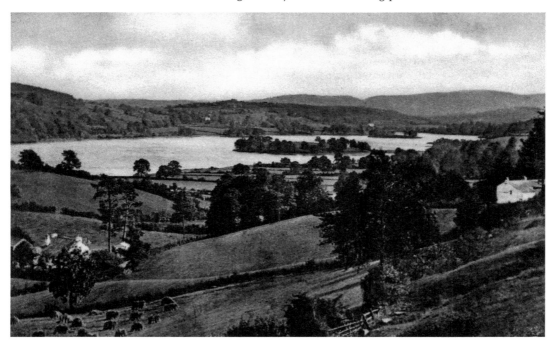

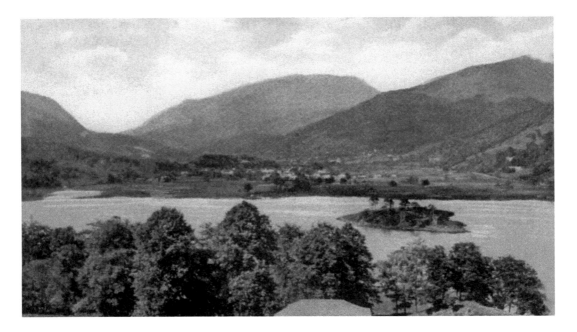

## Grasmere

Grasmere is located in the central Lakes and is almost 1 mile long and almost 1/2 mile wide. The lake is both fed and drained by the River Rothay, which flows through Grasmere into Rydal Water and onwards to Windermere. The village of Grasmere sits on the lake's northern shore and gives the lake its name. Interestingly, the lake is home to a singular island known as The Island, which was originally sold in 1893 to a private bidder, angering many locals including Canon Hardwicke Drummond Rawnsley, who believed that it should have been kept for public use. His feelings were so strong that he became a founding member of the National Trust and uniquely the island was gifted back to the National Trust in 2017.

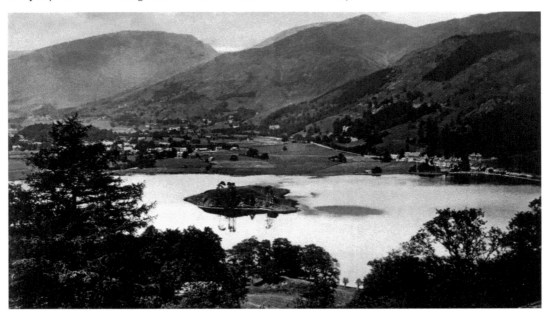

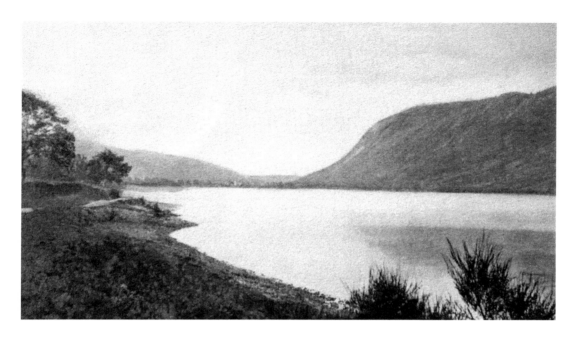

Haweswater

Unusually for the Lake District, Haweswater is one of only a handful of man-made reservoir lakes. It measures around 4 miles long and 1/2 mile wide and the current lake sits on the site of an earlier natural lake. Construction of the dam was started by the Manchester Corporation in 1929, who chose the Mardale Valley as the location for their new reservoir, which was needed to provide a large water supply in the North West. The development caused huge outcry from local residents and farmers whose land and villages were to be flooded once the dam was filled. It was completed in 1935.

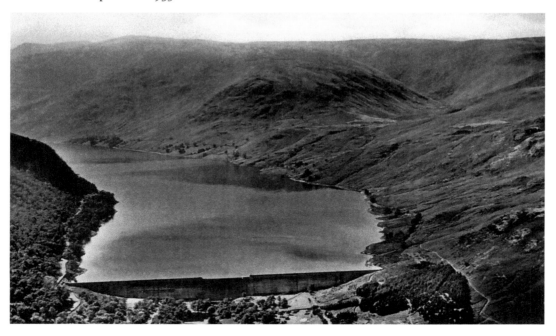

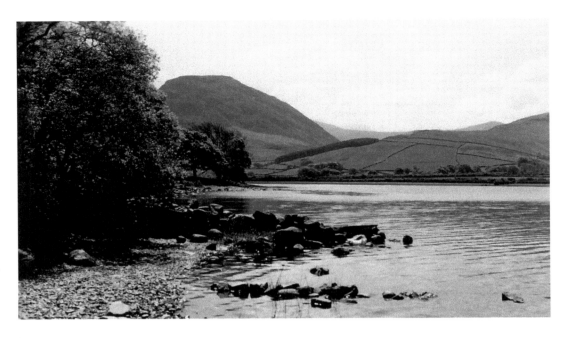

Loweswater
Loweswater is one of Lakeland's smaller and least visited lakes with a length of just over 1 mile
and a width of around 1/3 mile. The lake is drained by Dub Beck, which eventually becomes Park
Beck and drains into the northern part of Crummock Water. The small village of Loweswater is
located close to the southern end of the lake, with the town of Cockermouth close by. The fells
surrounding the lake include Mellbreak, Blake Fell and Burnbank Fell. On the south side of the
lake is the small forest of Holme Wood, home to Holme Force waterfall.

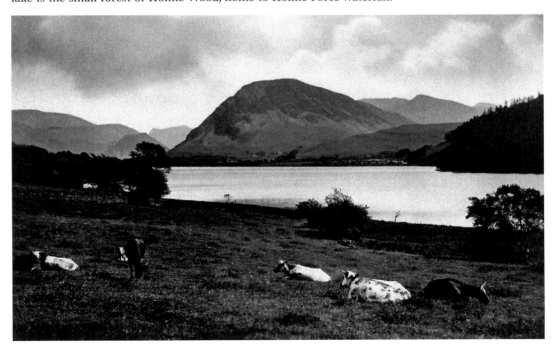

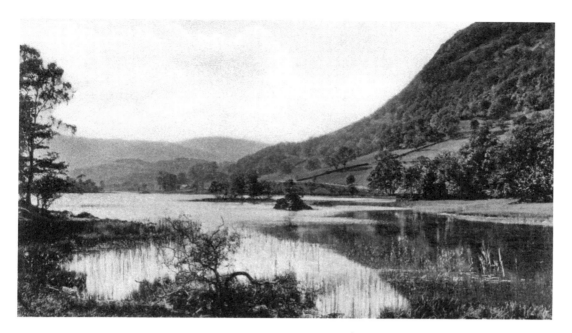

## Rydal Water

Rydal Water is located in the central Lakes and is one of the smallest lakes, measuring around 3/4 mile long and 1/4 mile wide. The lake is fed by the River Rothay, which flows from Grasmere Lake through Rydal Water and downstream towards Windermere. The lake is located close to the hamlet of Rydal and over the centuries was also known as Routhmere. Interestingly, the lake is owned by two groups of people. The northern section forms part of the Rydal Hall estate and is reserved solely for the residents of the hall. The southern part is leased to the National Trust by the Lowther Estate.

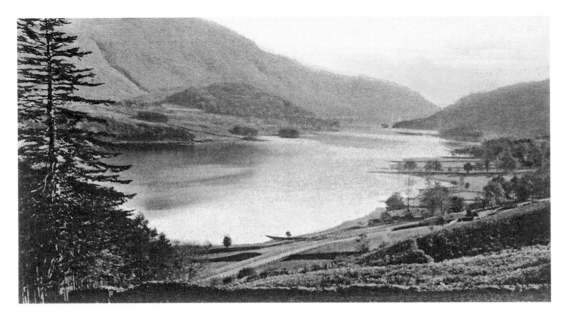

## Thirlmere

Thirlmere is one of the few reservoir lakes in the Lake District and is located on the site of an earlier lake, known over the centuries as Wythburn Water, Thirle Water and Leathes Water. The current lake is 3 3/4 miles long and around 0.1 mile wide. The history of the lake dates back to 1863 when a pamphlet was printed arguing that Thirlmere and Haweswater should be made into reservoirs with the water being transported to provide a source of clean water for London. In 1875 John Frederick Bateman suggested that Manchester and Liverpool could have a supply of water from Haweswater and Ullswater, but due to disagreements this did not happen. It was the Manchester Corporation who decided to construct a dam at the northern end, providing Manchester with a supply of clean water via the Thirlmere Aqueduct. The dam was officially opened in 1894 and the reservoir and the aqueduct are still used to provide water to the Manchester area.

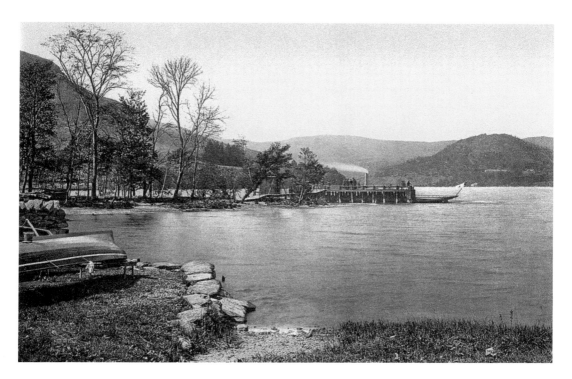

## Ullswater

Ullswater is located in the north-eastern Lakes and is the second largest in Lakeland at around 9 miles long and 3/4 mile wide with the water draining into the River Eamont to the north. Around the edges of the lake are several small villages including Pooley Bridge, Patterdale and Glenridding, a popular destination with walkers and climbers.

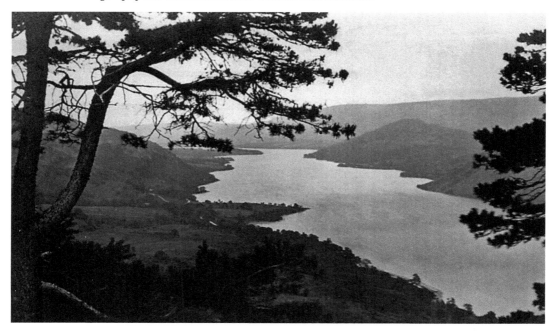

Ullswater II
The lake is arguably one of the most popular and least populated of the lakes due to its location between the towns of Windermere to the south and Penrith to the north. It is also located off the northern foot of the famous Kirkstone Pass, which gives it a unique character. On the western side of the lake is Helvellyn, one of the most visited mountains, as well as the famous Aira Force waterfall.

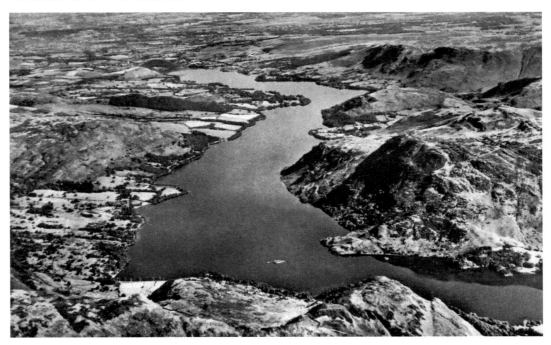

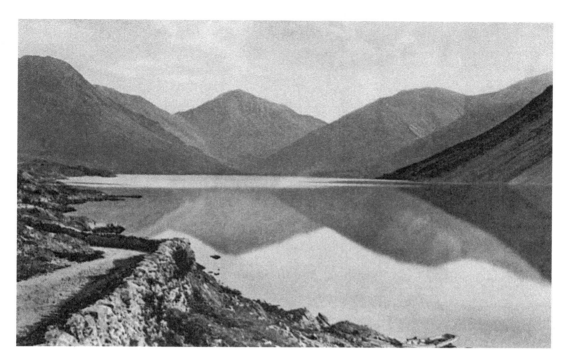

Wastwater

Wastwater is located in the western Lake District with a length of just over 3 miles and a width of nearly 1/2 mile. The lake is also notable for being the deepest lake in England with a depth of 79 metres and is owned by the National Trust. Its location in the Wasdale Valley means that it lies close to some of the highest mountains in the Lakes, including Great Gable and Scafell Pike.

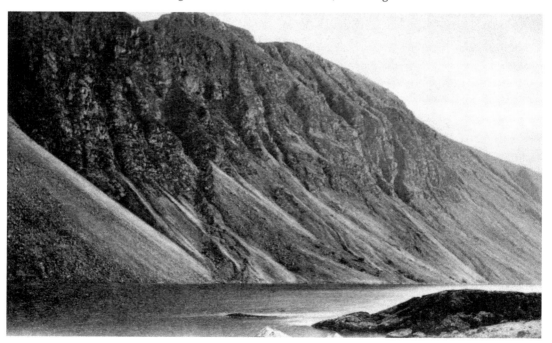

# CHAPTER 4

# MOUNTAINS AND VALLEYS

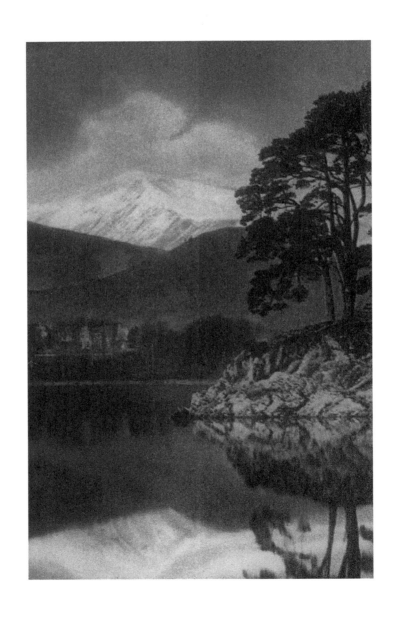

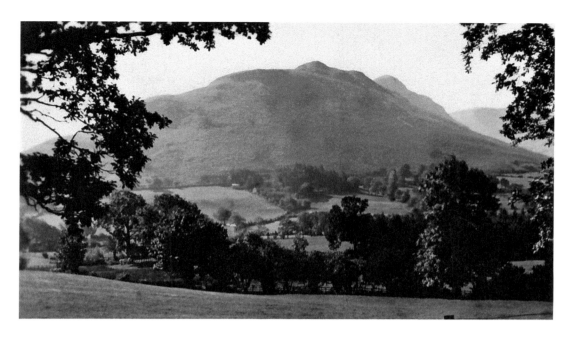

## Catbells

Catbells is well known as being one of the more accessible fells, making it a popular destination for tourists. It is one of the smallest mountains in the Lake District with a height of 451 metres and has a long association with the mining industry in Lakeland. The nearby town of Keswick is located around 3 miles north-east of the fell. It has been home to several mines over the centuries. On the eastern side are the Brandlehow and Old Brandley mine and on the western side is Yewthwaite mine, which is surrounded by large spoil heaps and shafts, making it a dangerous area to visit. The mines around Catbells closed during the 1890s.

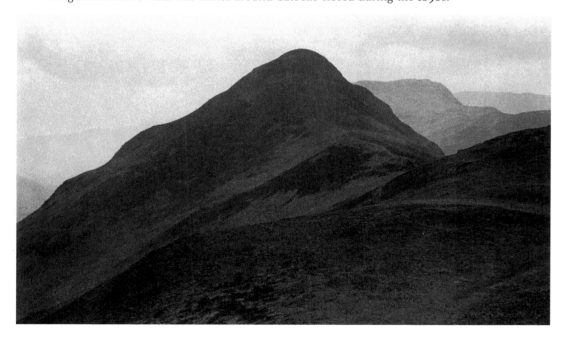

## Coniston Old Man

Coniston Old Man is a popular mountain with a height of 803 metres and is located west of the Lakeland village of Coniston and its namesake lake, Coniston Water. Over the centuries the fell has been known as The Old Man of Coniston or more simply as The Old Man. The mountain has a long history of mining with a history stretching back centuries, the remains of which can still be seen around the north-eastern side.

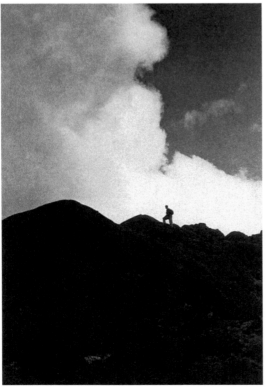

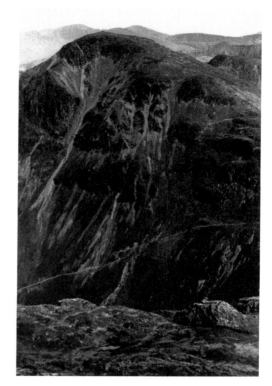

## Great Gable

Great Gable is one of the most popular
mountains in the Lake District with a height
of 899 metres and is located in the Western
Fells. The mountain summit is covered with
boulders and the highest point is marked by a
cairn made of rocks. Originally the mountain
was privately owned, but in 1924 the members
of the Fell and Rock Climbing Club bought
3,000 acres of land that included the mountain.
They donated it to the National Trust. The club
also placed a memorial plaque at the summit,
dedicated to the members who died fighting in
the First World War.

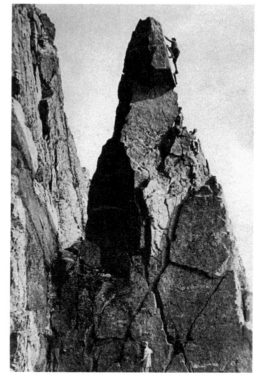

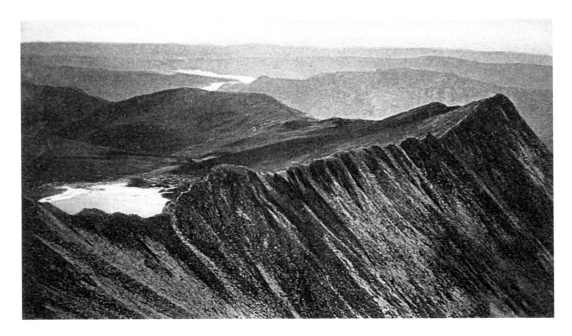

## Helvellyn

Helvellyn is the third tallest mountain in the Lake District and England and reaches a height of 950 metres. It is one of the favourite routes for climbers and is most famous for the part of the route that crosses Striding Edge. Due to the difficult nature of the route, which can involve scrambling, it has become a well-known accident spot. Unusually, the former county boundary between Westmorland and Cumberland follows the length of the Helvellyn Ridge. Another lesser-known event took place in 1926 when a small aircraft landed and then took off from the summit.

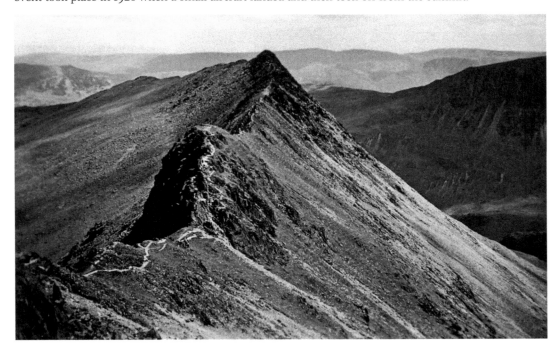

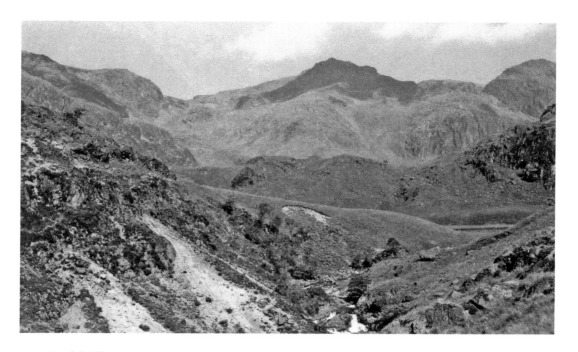

## Scafell Pike

Scafell Pike is the tallest mountain in Lakeland and also in the whole of England. Its peak reaches a height of 978 metres and it forms part of the Southern Fells. The mountain is also home to Broad Crag Tarn, which sits at around 820 metres, making it the highest standing body of water in England. The mountain's summit was donated to the National Trust in 1919 by Lord Leconfield to commemorate the sacrifice of all the Lakeland men who died fighting during the First World War. Nowadays the mountain is one of the three peaks that forms the National Three Peaks Challenge.

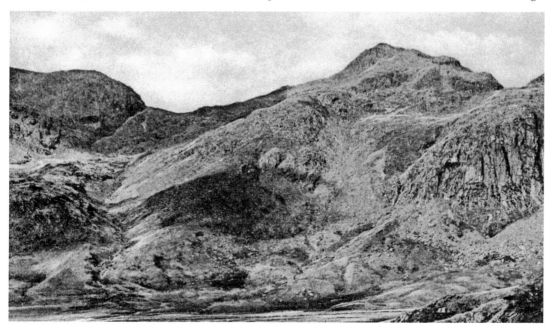

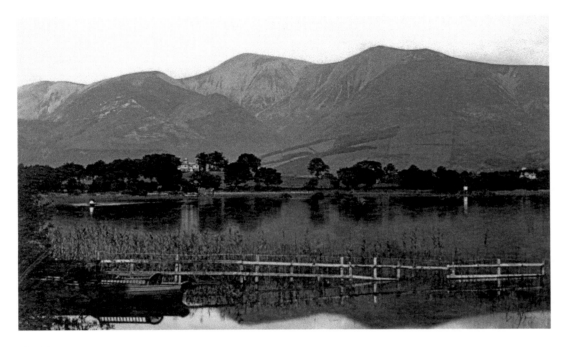

## Skiddaw

Skiddaw is the sixth tallest mountain in the Lake District with a height of 931 meters. The slopes of the mountain are rounded and its ridges are covered in loose stone. To the south lies the town of Keswick and Bassenthwaite Lake can be found to the west. The mountain also gives its name to the nearby Skiddaw Forest and the area is also well known for its slate, known as Skiddaw Slate, which is used to produce percussion instruments known as lithophones.

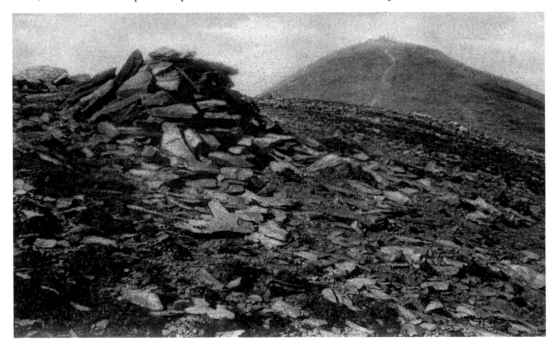

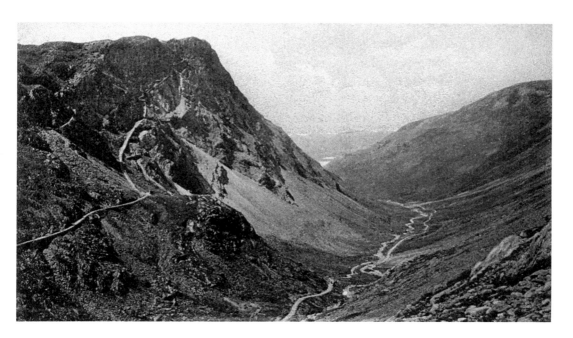

Honister Pass

Honister Pass is one of the most famous mountain passes in Lakeland and connects the Borrowdale Valley to the southern end of Buttermere Lake. It reaches a height of 356 metres and has a steep gradient of up to 25 per cent in places. In the days before the construction of the road, it was nothing more than a stone track, making it particularly dangerous. The pass is also home to Honister Slate Mine, one of the best-preserved mines in the Lakes and famous for its Westmorland green slate. The area has seen mining since 1728 and the current mine closed in 1989. It was reopened as a visitor attraction and small-scale factory producing roof slates in 1997.

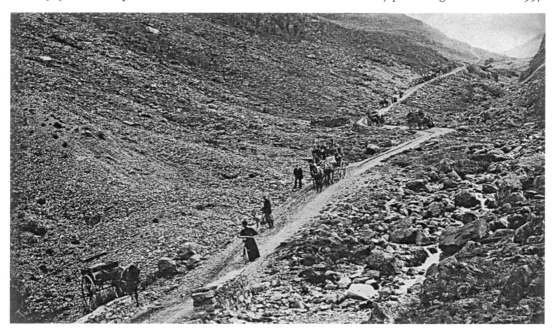

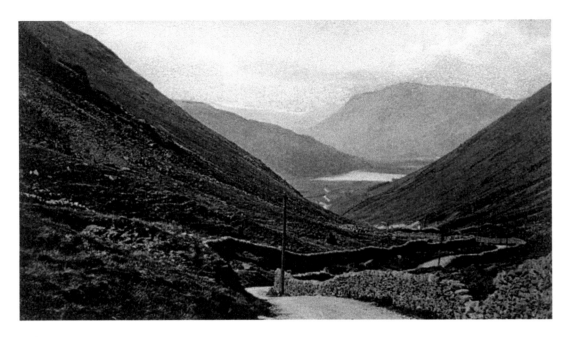

Kirkstone Pass

One of the most unusual routes in the Lake District is the Kirkstone Pass, which takes tourists across the high fells from Windermere to Ullswater. The pass reaches a height of 454 metres and is famous for its old coaching inn located at the top of the route. It is named after a boulder located close to the inn that people say looks like a steeple of a church. In Old Norse language, the word for church was 'kirk'. The top of the pass is also the start of another pass known as The Struggle, which is notorious for its tight bends and narrow route as it travels towards the town of Ambleside.

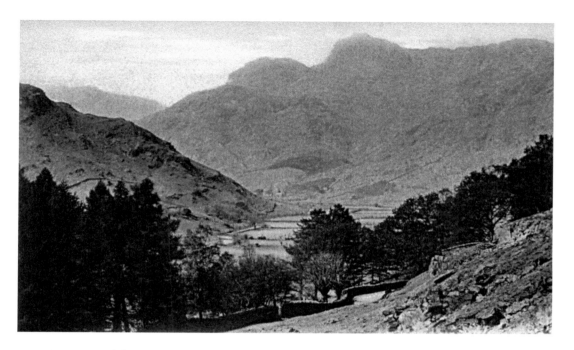

## Great Langdale

Great Langdale is one of Lakeland's most picturesque valleys and is a popular destination with walkers and fell runners. It is home to many notable features including the Langdale Pikes and Dungeon Ghyll Force waterfall. The area has a rich history and was famous in the Neolithic period for the manufacturing of stone axes and was also a centre of slate mining through the centuries with several quarries having existed in the area. The valley is home to several small settlements including Chapel Stile and Elterwater, with the nearby town of Ambleside located around 2 miles to the east.

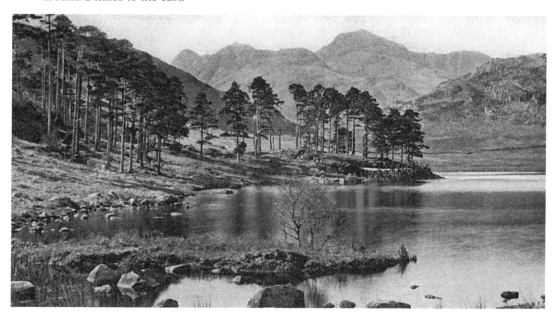

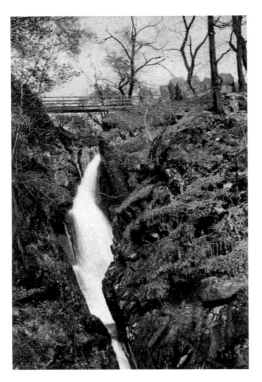

Aira Force
The waterfall is one of the most well known in Lakeland with a height of around 22 metres. The area around the waterfall known as Gowbarrow Park was purchased by the National Trust in 1906. There are several paths that allow tourists to walk up the hillside to view the waterfall from various locations, one of which passes a Wish Tree, which is a fallen tree where visitors place coins and hammer them into the trunk with stones for good luck.

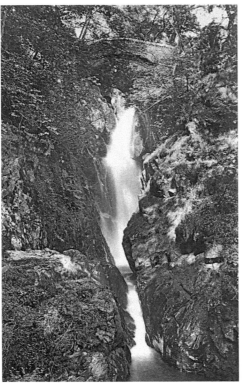

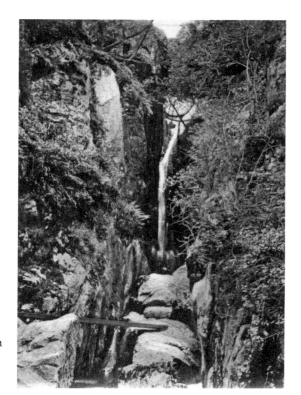

### Dungeon Ghyll Force

Dungeon Ghyll Force is one of the most impressive waterfalls in the Lake District with a height of around 12 metres and fed by Dungeon Ghyll. Dungeon Ghyll starts on the fell slopes between Harrison Stickle and Loft Crag and was made famous by William Wordsworth in his poem 'The Idle Shepherd Boys'.

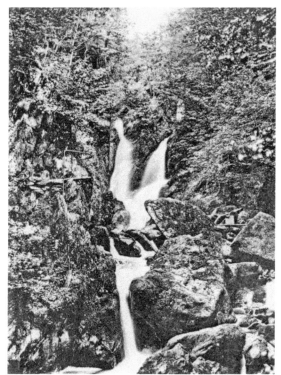

### Stock Ghyll Force

In the centre of Ambleside is the notable Stock Ghyll Force with a height of around 21 metres. The waterfall is located close to the Salutation Hotel and flows down through the town past the old mills and underneath the famous Bridge House towards the River Rothay. It is so powerful that it was originally used to power twelve watermills that produced various goods including paper, fabric, ground corn and wooden bobbins.

# CHAPTER 5
# LAKELAND TOWNS
# AND VILLAGES

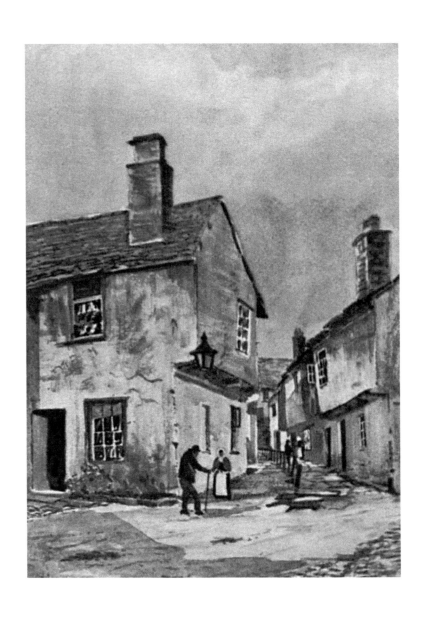

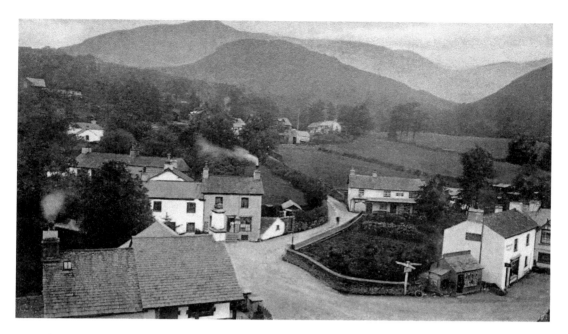

Coniston

Coniston is one of Lakeland's most picturesque villages and is located at the northern end of Coniston Water, with the nearby mountain known as Coniston Old Man located to the west of the village. The area around the village has a long history connected to mining slate and ore with evidence dating back to the Roman occupation and possibly the Bronze Age. The village developed over the centuries as these industries grew and was connected to the Coniston railway, which linked the village to Broughton-in-Furness between 1859 and 1962.

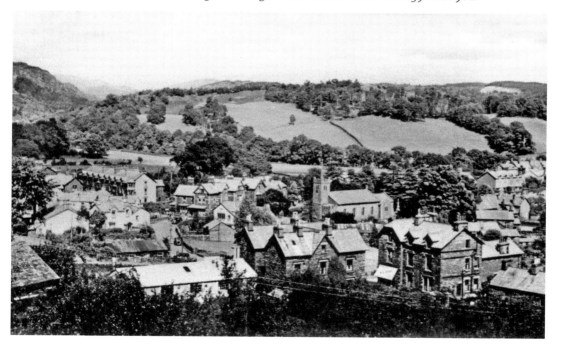

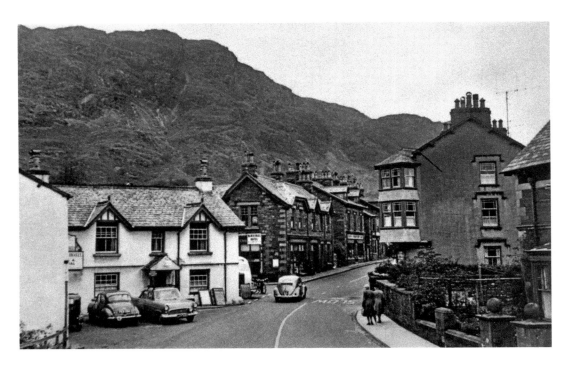

## Coniston II

Coniston is a very popular destination with climbers and walkers due to its location close to Grizedale Forest and Dow Crags. The village is also famous for being home to Brantwood, the home of John Ruskin which is located on the eastern side of the lake. It is also notable as being the base for the world water speed record attempts of Malcolm and Donald Campbell.

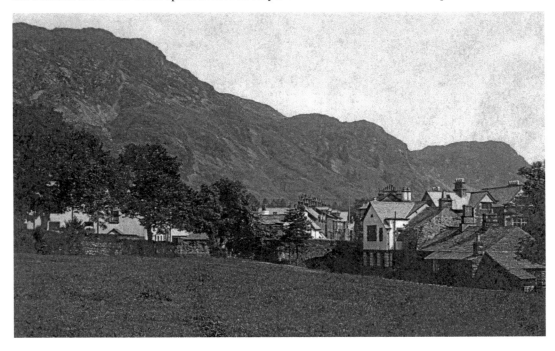

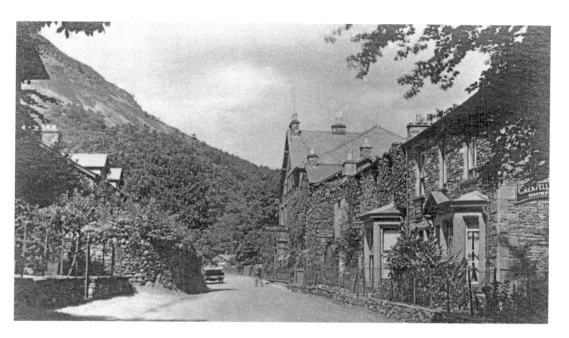

## Glenridding

Glenridding is a popular destination for walkers and climbers wanting to tackle Helvellyn, but is less well known among tourists. It is located towards the southern end of Ullswater and is quite small with only a few hotels, hostels and shops. It is home to the Ullswater Steamers, which sail on the lake between Glenridding and Pooley Bridge located at the northern end of the lake. The area was once a hub of local mining and was home to Greenside Mine, which was one of the largest lead mines in Lakeland. Ore was first discovered in the eighteenth century and the site was operational until 1962. In December 2015, the town was devastated by severe flooding caused by Storm Desmond.

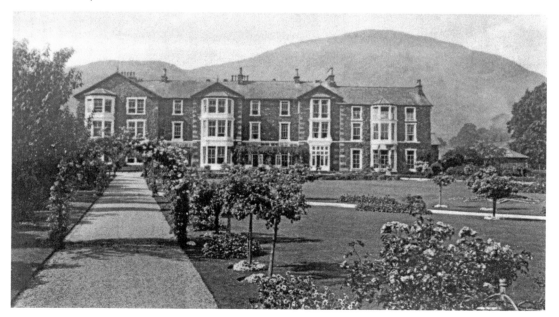

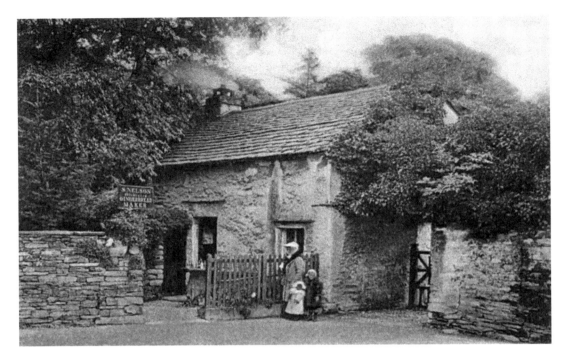

## Grasmere

Grasmere is one of Lakeland's most famous and popular villages, known for its connection to poet William Wordsworth who resided in the nearby Dove Cottage. The village is situated on the River Rothay and is close to the lake of Grasmere, which lies to the south of the village. It is also located along the main transport route from Ambleside to Keswick and Helm Crag, sometimes referred to as Old Lady at the Piano or The Lion and the Lamb due to its shape.

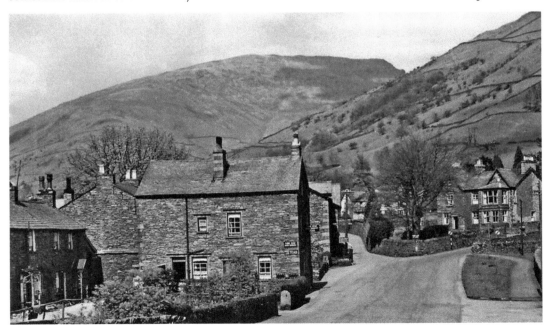

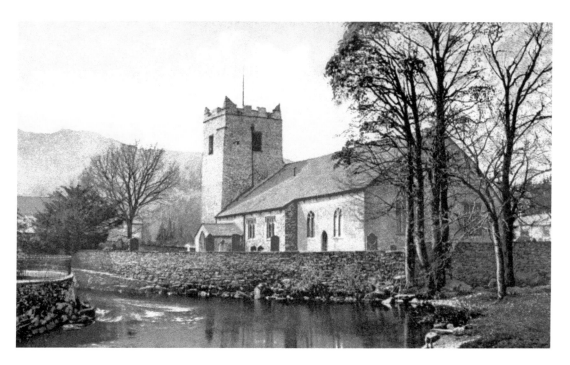

## Grasmere II

The village is also famous for Grasmere gingerbread, which was invented by Sarah Nelson in 1854. She made it by hand at her home, which was known as Church Cottage. Over the years she developed a strong reputation for her gingerbread and once the railways arrived in Lakeland tourists flocked to Grasmere to taste her baking. Close to the gingerbread shop is St Oswald's Church. In the south-east of the churchyard are the graves of William Wordsworth and his wife Mary.

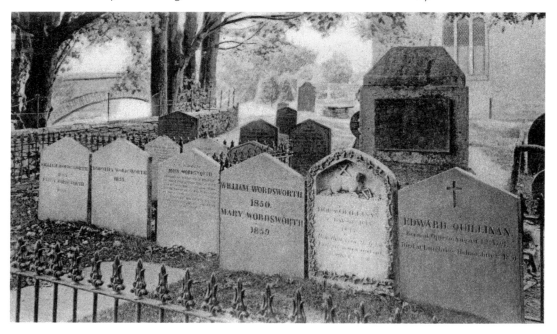

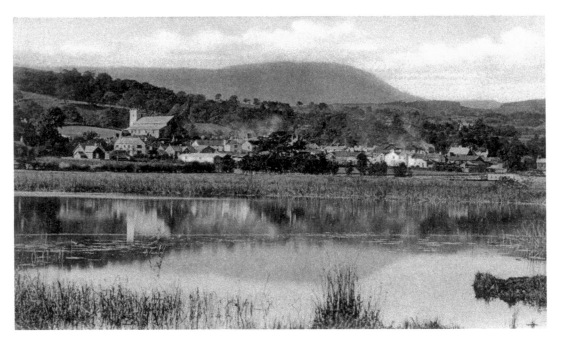

## Hawkshead

Hawkshead is a small village located at the northern end of Esthwaite Water and it has a strong connection with the local farming industry. During the Middle Ages the lands formed part of the estate owned by Furness Abbey and it was during this period that the town developed and began to hold a wool market, becoming a market town around 1608.

Hawkshead II

The centre of the village is home to many old and usual buildings, including the old Hawkshead Grammar School. The school was founded in 1585 and closed in 1909. One of its most famous students was the poet William Wordsworth. During the eighteenth and nineteenth century the town grew and became a popular tourist destination due to its close proximity to Windermere. The writer Beatrix Potter also owned the nearby Hill Top Farm.

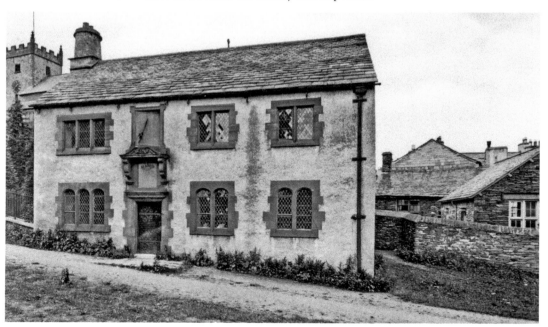

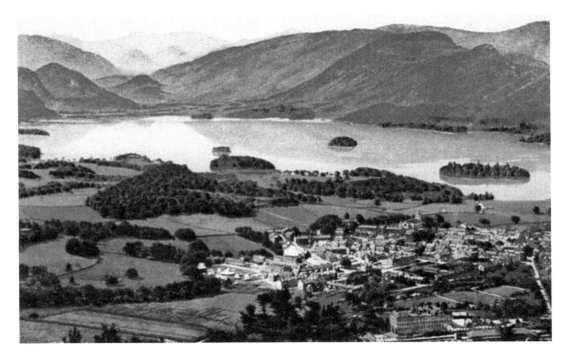

## Keswick

Keswick is located to the north of Derwent Water and has been an important market town since the Middle Ages. It was granted a market charter by Edward I in 1276 and the earliest records of the town date from the thirteenth century. There is some evidence that suggests that the area was occupied in prehistoric times and later during the Roman occupation. During the Tudor period the town became an important hub for mining. The town is also famous for its pencil manufacturing, which started as a small-scale industry and later grew into a major industry.

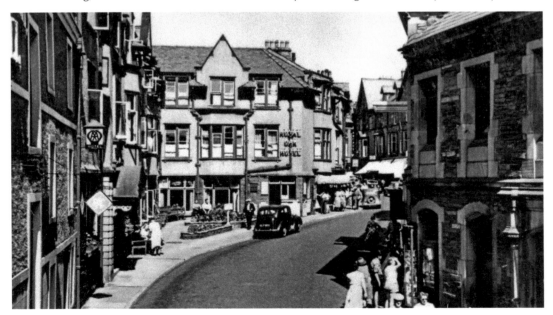

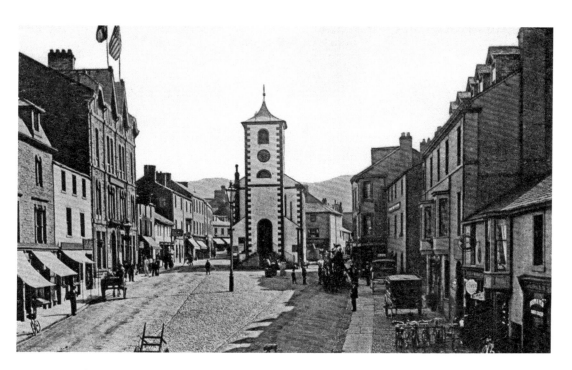

## Keswick II

Keswick underwent a huge change with the introduction of tourism to the area during the eighteenth century. During this period turnpikes were constructed throughout the Lake District, which for the first time allowed tourists to visit the area more easily. In the nineteenth century transport links were further improved with the opening of the Cockermouth, Keswick and Penrith Railway, which served the town between 1865 and 1972. In the town centre you find The Moot Hall, the most famous structure in Keswick. The current building is the third to be built on the site and dates to 1813, with the two earlier buildings constructed in 1571 and 1695, respectively.

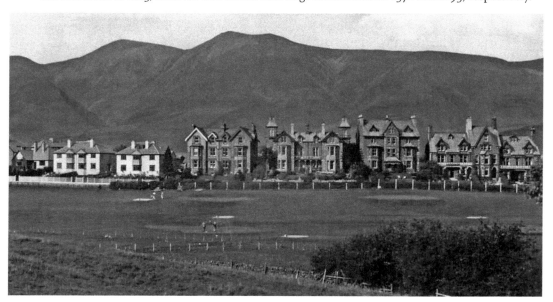

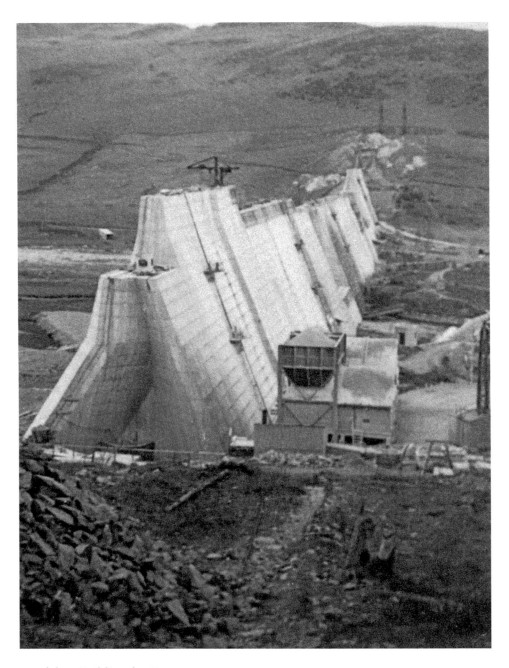

Mardale – Building the Dam

The idea of building a dam in the area was first considered in 1866 but did not progress. In 1919, parliament passed an act that allowed the development of the project to start, but it took a further ten years before construction was undertaken. Work at the site began in 1929 but stopped in 1931 before once again resuming in 1934. One of the major hurdles in building the reservoir in the Mardale Valley was the village of Mardale. The development caused a huge outcry from local residents and farmers, whose land and villages were to be flooded once the dam was filled.

Mardale – The Lost Village

The village of Mardale in the Lake District disappeared when the Haweswater valley was flooded in 1935. The most famous building in the village was the Dun Bull pub, which was demolished along with all the other buildings in 1935. The church was demolished with some of the stone being reused, while the graveyard at the church was removed and the bodies were reburied in Shap.

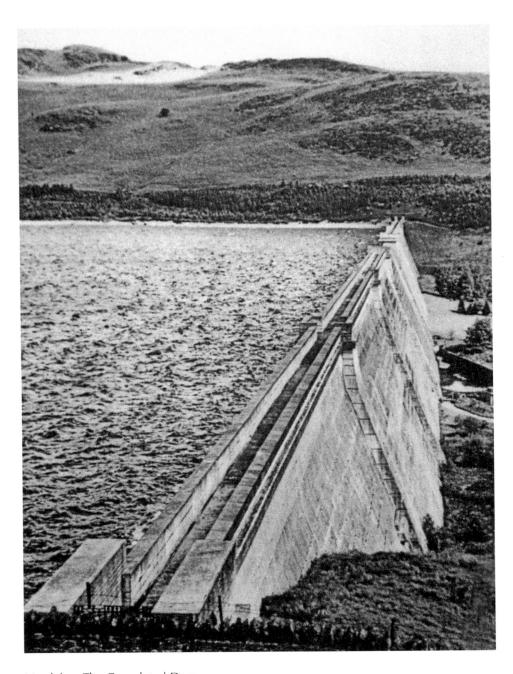

Mardale – The Completed Dam

Upon the completion of the dam in 1935, it measured around 470 meters long and almost 27 metres high. Once the newly constructed dam was filled, the local water level rose by 29 metres. When full it can hold around 84 billion litres of water and currently supplies around 25 per cent of the water used in the North West. During periods of extreme drought when water levels drop dramatically, the remains of some of the original roads, bridges and building locations can be seen. The area now forms part of a large RSPB nature reserve.

## Staveley

Staveley is one of Lakeland's lesser-known villages and lies close to the nearby town of Kendal. It sits close to the River Kent and River Gowan, which join together at the southern end of the village. Through the centuries the village has also been known as Staveley-in-Westmorland and Staveley-in-Kendal. The area surrounding the village has a history dating back to the prehistoric period when the land was first farmed, and later during the Roman occupation the area was connected by a road network. Later, during the eighteenth century, the village was connected by a new turnpike road and in the nineteenth century was connected by the new Kendal–Windermere railway.

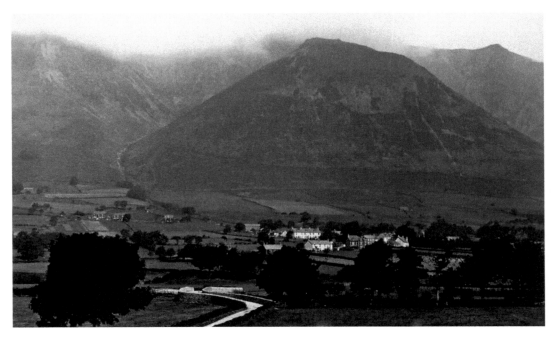

## Threlkeld

Threlkeld is a small village that lies to the south of Blencathra and east of Keswick, with the River Glenderamackin to the south of the village. The village was served by the Cockermouth, Keswick and Penrith Railway between 1865 and 1972. The village was home to Threlkeld Quarry, which opened in 1870 to supply railway ballast and later provided stone for the Thirlmere reservoir development. The quarry closed in 1982 and is now home to the Threlkeld Quarry & Mining Museum.

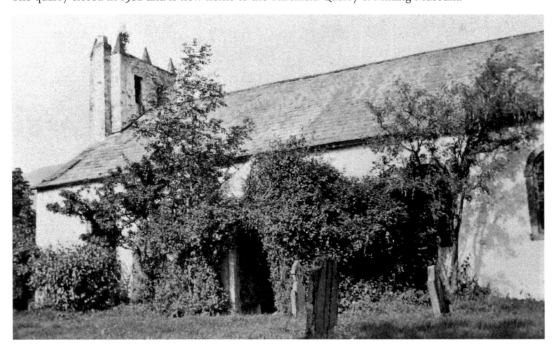

# CHAPTER 6

# NOTABLE SITES
# AND BUILDINGS

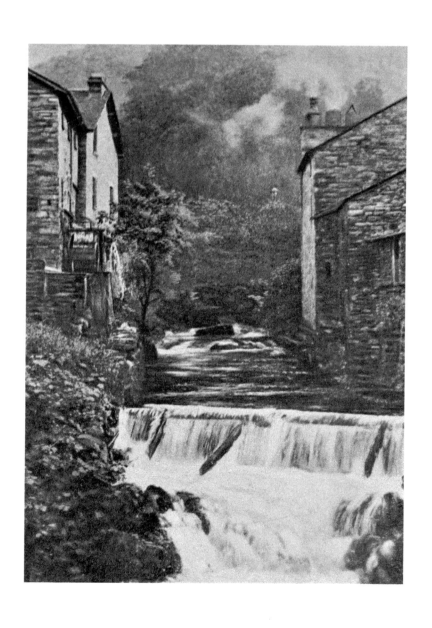

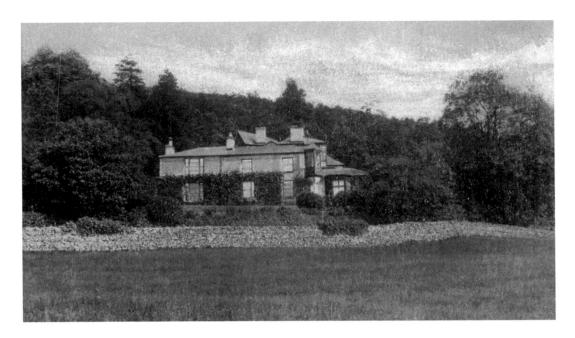

Brantwood

Brantwood is famous for being the home of Victorian artist and art critic John Ruskin. The site was originally developed by Thomas Woodville, who first constructed a house on the site at the end of the eighteenth century. Later, in 1833, the house and estate underwent a redevelopment and expansion. Interestingly, the house had been home to many unusual characters over the years, including artist and social reformer William James Linton and the poet and Egyptologist Gerald Massey. In 1871, John Ruskin purchased the house and immediately set about repairing and altering it. He decorated the interior of Brantwood with art including paintings by Gainsborough and Turner, as well as more unusual collections including minerals and seashells.

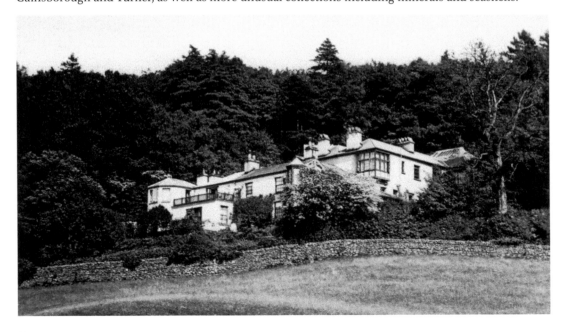

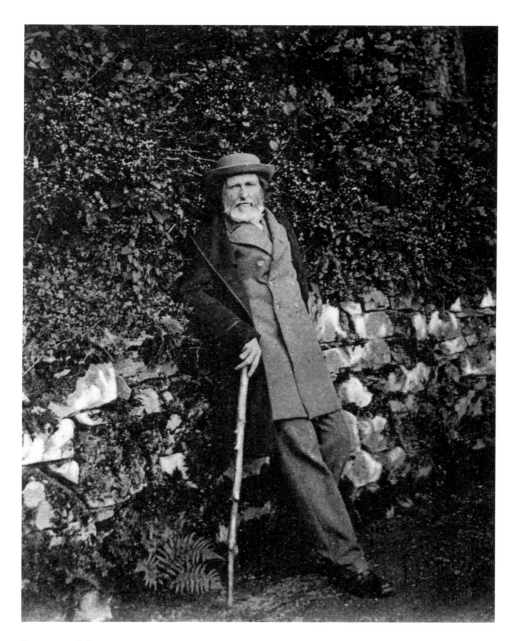

## Brantwood II

In 1878, a new dining room was constructed in the southern part of the house and later, in 1890, a second storey was constructed. When Ruskin died 1900, his estate and house were inherited by the Severn family. In his will he stated that Brantwood should be open for thirty days a year for visitors to explore. However, his wishes were not kept and the family sold off many pieces of his art collection. Later, when Arthur Severn died in 1931, the remaining contents of Brantwood were auctioned. Emily Warren, who was a pupil of Ruskin's, successfully petitioned to have the house made into a museum. It was purchased by John Howard Whitehouse, who was the founder of Bembridge School and the Birmingham Ruskin Society. He established the Brantwood Trust in 1951.

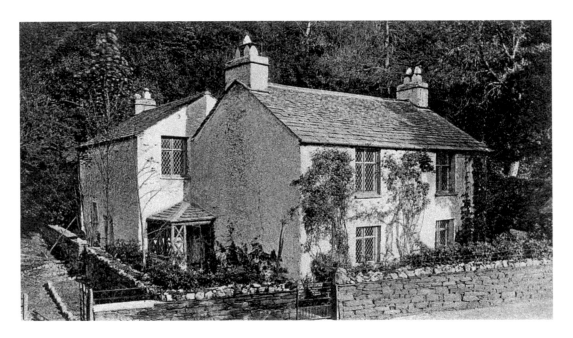

## Dove Cottage

On the outskirts of Grasmere is Dove Cottage, once home to poet William Wordsworth. The house was constructed during the seventeenth century on the main route between Keswick and Ambleside. The building was constructed using local slate and stone, with four rooms on each floor. Originally the building housed an inn named the Dove and Olive, which closed in 1793. Wordsworth came across the building in 1799 while exploring Lakeland with his friend, the poet Samuel Taylor Coleridge. Wordsworth wanted to find a place where he could spend time reconnecting with his sister, Dorothy. He saw that the house was vacant and decided to rent it at a cost of £5 per year.

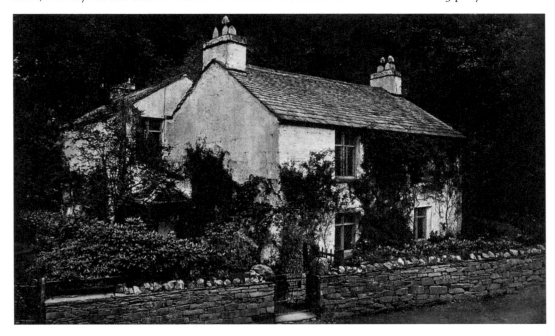

## Dove Cottage II

Later, in 1802, when he married his wife Mary, she and her sister Sara moved into Dove Cottage with William and Dorothy. The cottage became a home and later Mary gave birth to three children: John, Dora and Thomas. Eventually as the family grew, the cottage was no longer suitable. The family moved out in 1808. Upon their departure the house became home to another famous resident: writer Thomas de Quincey. In 1890, the cottage was purchased by the Wordsworth Trust, who reopened it as a museum.

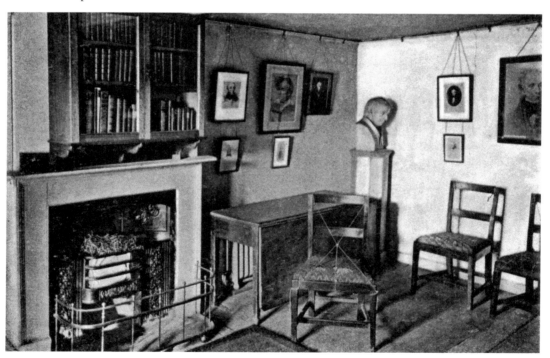

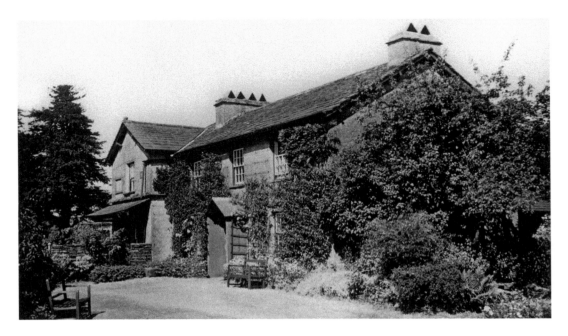

## Hill Top

In the small village of Near Sawrey, close to Hawkshead, is Hill Top, famous for being the home of Beatrix Potter. The house was originally constructed during the seventeenth century and served as a farmhouse with surrounding farmland. Beatrix Potter purchased the working farm at the beginning of the twentieth century and used it as a retreat away from the hustle and bustle of London. In 1913, she married William Heelis, a solicitor from Hawkshead, and spent much of her later life at the house. Upon her death at the house in in 1943, she left the house and her land to the National Trust.

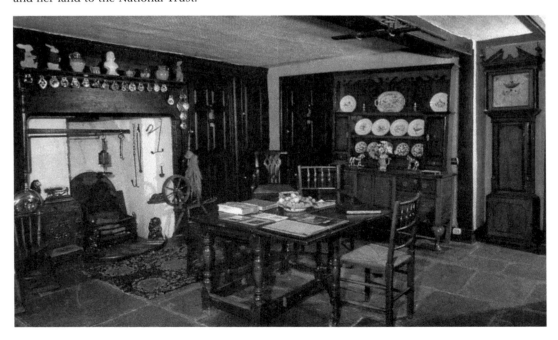

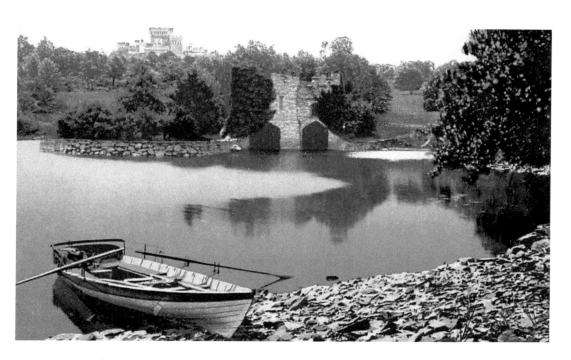

## Wray Castle

One of the least well-known yet impressive buildings in the Lake District is that of Wray Castle on the western side of Windermere. The castle and nearby Wray Church were built in 1840 by James Dawson, a surgeon from Liverpool. When he died in 1875, the house was passed on to his nephew Edward Preston and later passed to Edward's cousin Hardwicke Rawnsley, who was the vicar at Wray Church. In 1929, Wray Castle was given to the National Trust by Sir Robert Noton Barclay and used for various purposes through the years including being home to a youth hostel, a Merchant Navy training college and offices. Since 2011 it has been open to the public as a visitor attraction.

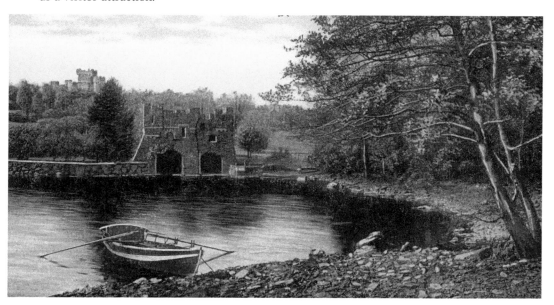

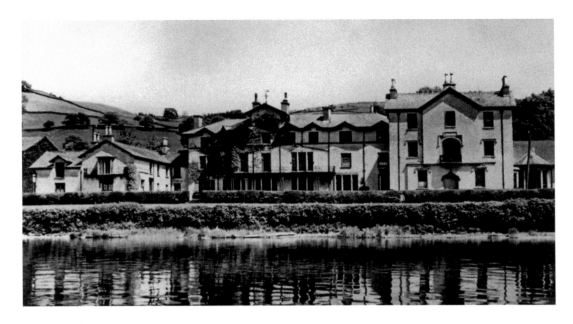

## Low Wood

One of the most spectacular hotels on the edges of Windermere is Low Wood, located on the main route between the towns of Windermere and Ambleside. The hotel has a long history dating back to the eighteenth century when a hostelry developed at the site. The creation of the Kendal to Keswick turnpike road in 1762 fuelled a boom in tourism and the site was further developed to accommodate tourists. The hotel played host to many important guests over the centuries including J. M. W. Turner, William Wordsworth and John Ruskin, to more recent guests including Tom Cruise and Joan Collins.

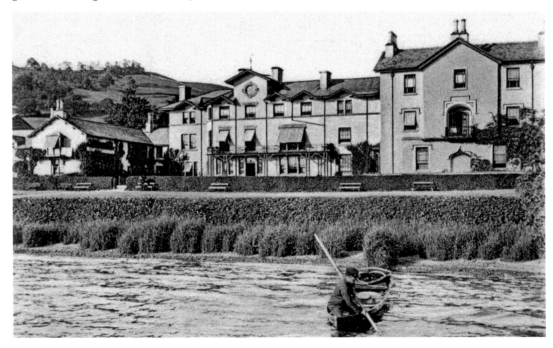

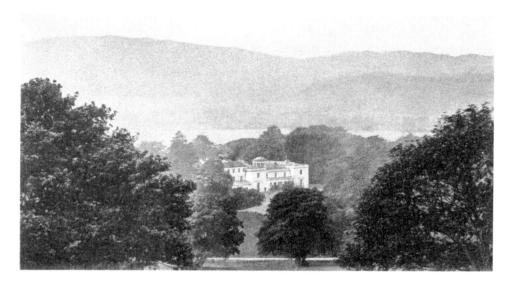

## Storrs Hall

Storrs Hall, standing close to Windermere, is one of the most famous of all the halls to be found in the Lake District. The house was originally built in the 1790s by Sir John Legard, a prominent landowner from Yorkshire. Due to ill health he sold the house in 1804 to John Bolton, who was involved in the Liverpool slave trade. The house was used to entertain friends and family and he became well known for its lavish parties and boat regattas on Windermere, attended by notable guests including Sir Walter Scott and William Wordsworth. When Bolton died the house passed on to Elizabeth Bolton, who in turn passed it on to Revd Thomas Staniforth, her nephew, who lived at the house until 1887. After his death, and with no heirs, the house was sold off. Later, between 1940 and 1944, the hall was home to the boys and staff of St Hugh's School, Woodhall Spa, who had been evacuated during the Second World War. Nowadays the hall has been preserved and is now a hotel.

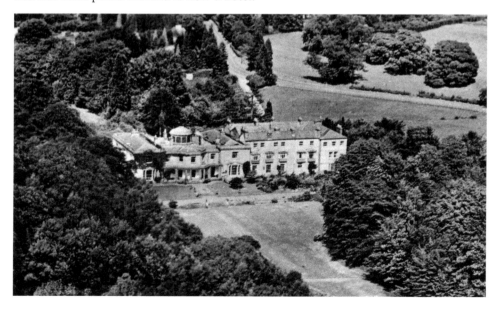

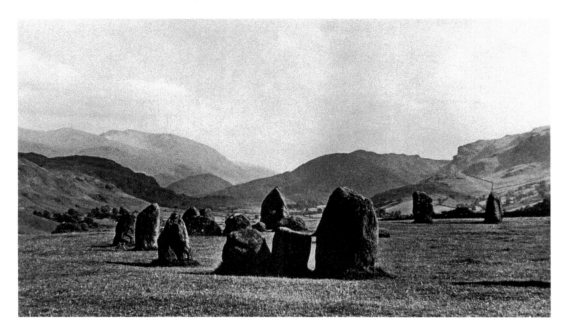

## Castlerigg Stone Circle

The Lake District is home to many important prehistoric sites including the inspiring stone circle at Castlerigg Stone Circle close to Keswick, sometimes referred to as Druids' Circle. The site dates to around 3200 BC and may possibly be one of the earliest constructed in Britain. There are thirty-eight slate stones with the tallest measuring 2 metres high and around 16 tons, and they are laid out in circular pattern around 32 metres wide. To the north is a gap in the stones, which may possibly have been an entrance. One of the most unusual features is the rectangle of stones within the main circle. The only known excavation at the site was undertaken in 1882 by W. K. Dover. The same year the site was one of sixty-eight sites listed for protection in the Ancient Monuments Protection Act 1882.

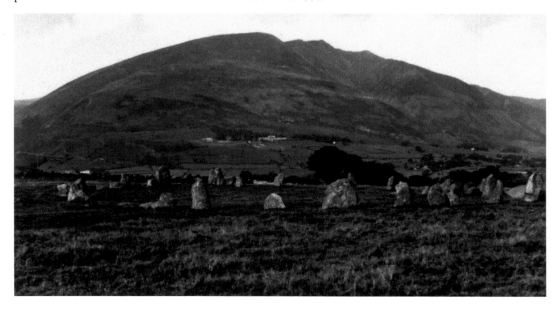

The Bridge House
The famous Bridge House in Ambleside is a seventeenth-century building originally built by the Braithwaite family to allow them access to their land on the other side of Stock Beck, as well as providing a store for apples from their orchard. Through the centuries the building has been used for many different purposes including a weaving shop, cobblers shop, and tearoom and was also used as a home for a family of eight. During the 1920s the building underwent restoration after funds were raised by locals.

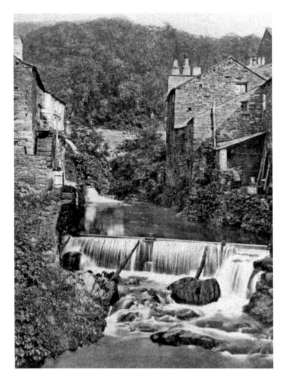

### The Watermill, Ambleside

This stretch of the river, with its powerful waterfall, has been utilised for centuries. During this period several mills were constructed to harness the power of the Stock Ghyll Force. The first record of a mill at the site dates to 1453 and mentions a mill that processed woollen cloth. Later, two other mills developed and supplied cloth to Kendal. Several other mills were also in operation and these milled corn and also produced wooden bobbins.

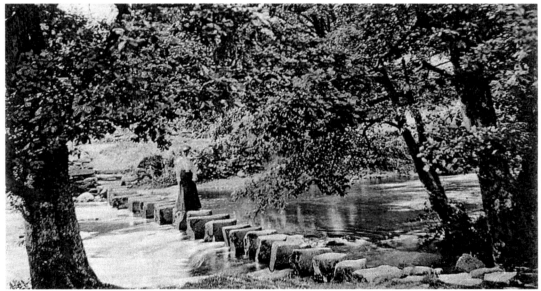

### Stepping Stones

On the outskirts of Ambleside close to the hamlet of Rydal is Stepping Stone Cottage, formerly known as Spring Cottage and located on the banks of the River Rothay. The house is most famous for being the home of William Wordsworth junior, son of the famous poet. One of the most unusual features of the location is the stepping stones outside the cottage that cross the river and provide a way of accessing the nearby route from Ambleside to Grasmere.

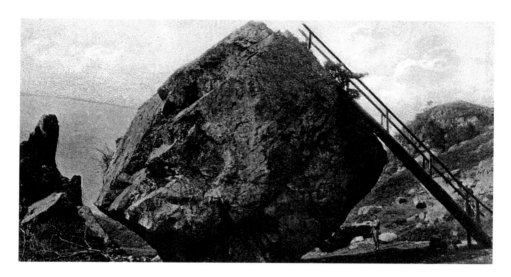

## The Bowder Stone

The Bowder Stone located in Borrowdale is arguably one of the Lake District's most unusual visitor attractions. The stone came to lie in its current location around 10,000–13,500 years ago when it broke loose from Bowder Crag and fell 200 metres to its present location. Its history dates back to 1798 when Joseph Pocklington attempted to make a new tourist attraction. He was very wealthy and slightly eccentric and had previously built a house on Derwent Island. He decided to buy the land and stone and built a large ladder that tourists could climb up allowing them to stand on the top for a small fee. At the same time he also constructed a hermitage as a counterpart to the 'druid' standing stone he had erected.

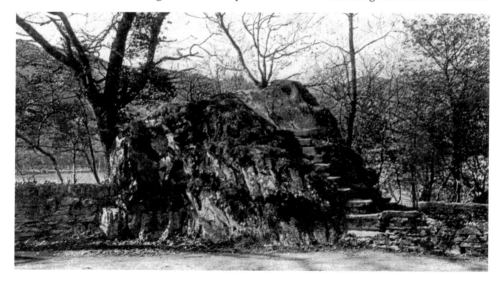

## Wordsworth's Seat

Another unusual tourist site in the Lake District is Wordsworth's Seat. Located close to the edge of Rydal Water on the main route from Ambleside to Grasmere is a large boulder with a set of steps carved into it. It was a supposed favourite place of William Wordsworth, who was believed to have made a deal with a local coachman. In return for money Wordsworth could be observed writing while he sat on the stone

# CHAPTER 7
# LAKELAND LIFE

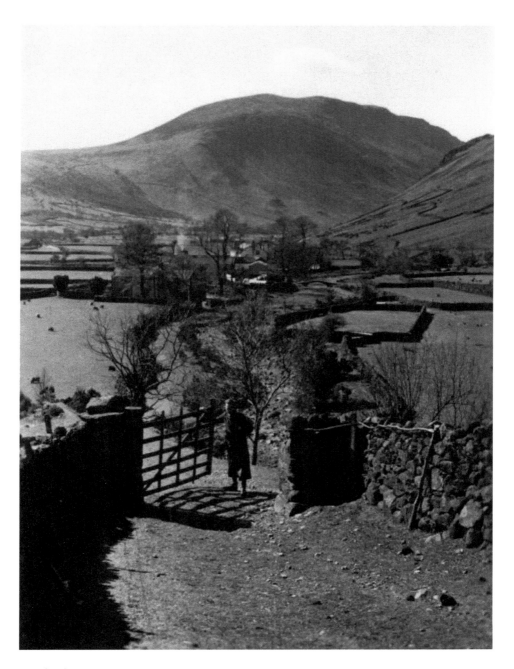

## Rural Life

Until the twentieth century Lakeland was still home to many remote and rural settlements and small communities. Over the centuries the residents had survived by using the local land and resources to provide them with everything they needed. For the inhabitants of the Lake District, the biggest industry was farming, which to this day is an extremely important industry.

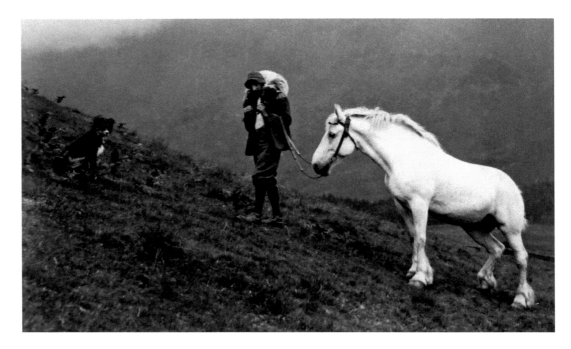

## Sheep Farming

Sheep farming is one of the most traditional industries in the Lakes. Sheep were bred for their wool, which was then transported and sold at the local charter markets in the surrounding towns including Kendal. Their meat also provided an additional source of income to the remote residents of Lakeland. When we think about sheep farming in the Lakes, the most famous breed is the Herdwick sheep, a native species of the Lakes. Their high-quality wool is renowned for its thick fibres and durability, ideal for creating layers of insulation.

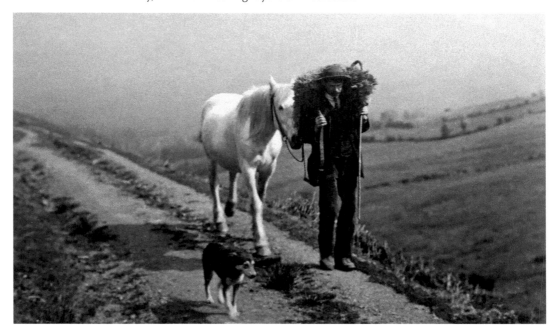

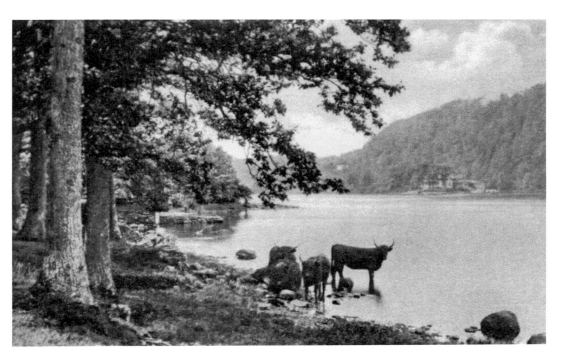

## Cattle Farming

The Lake District is also famous for cattle farming, with farms providing not only a plentiful supply of meat, but also a source of hides that could be sold for tanning and the manufacture of leather goods. Although a much smaller industry than sheep farming, it forms one of the most important agricultural industries in Lakeland.

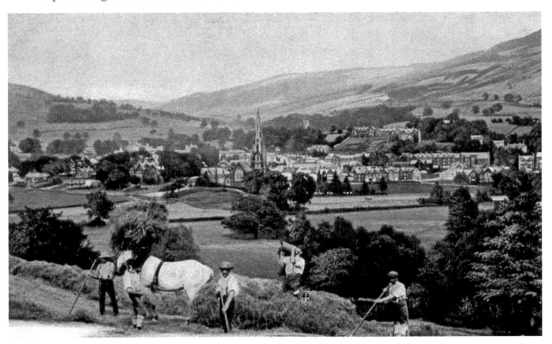

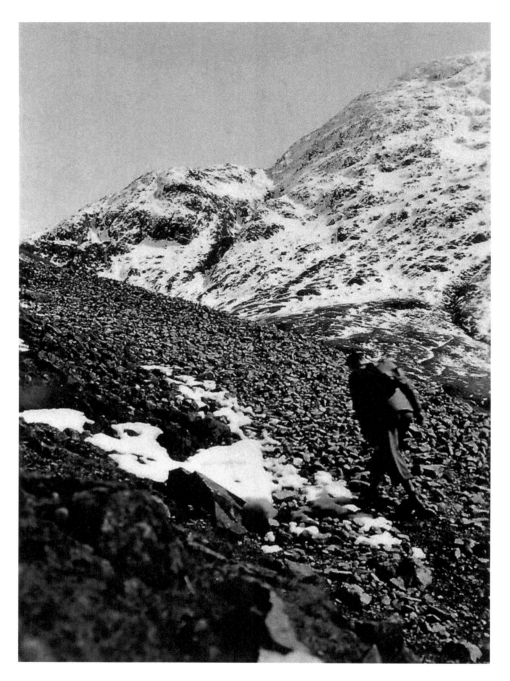

Walking in the Lakes

The Lake District and its rugged landscape has always been a draw for tourists seeking out something new. Its imposing peaks and craggy mountains were popularised by Alfred Wainwright, who recorded 214 mountains and fells of Lakeland and published them as a series of pictorial guides to the Lake District. The Lake District today remains a destination for walkers, climbers, bikers and even runners who want to get out and explore all that Lakeland has to offer.